Front endpaper Hoeschler Residence, St. Paul, MN.
Page 1 B Residence, Darien, CT.
Page 2 B Residence, Darien, CT.
Back endpaper Uyesugi Residence, Malibu, CA.

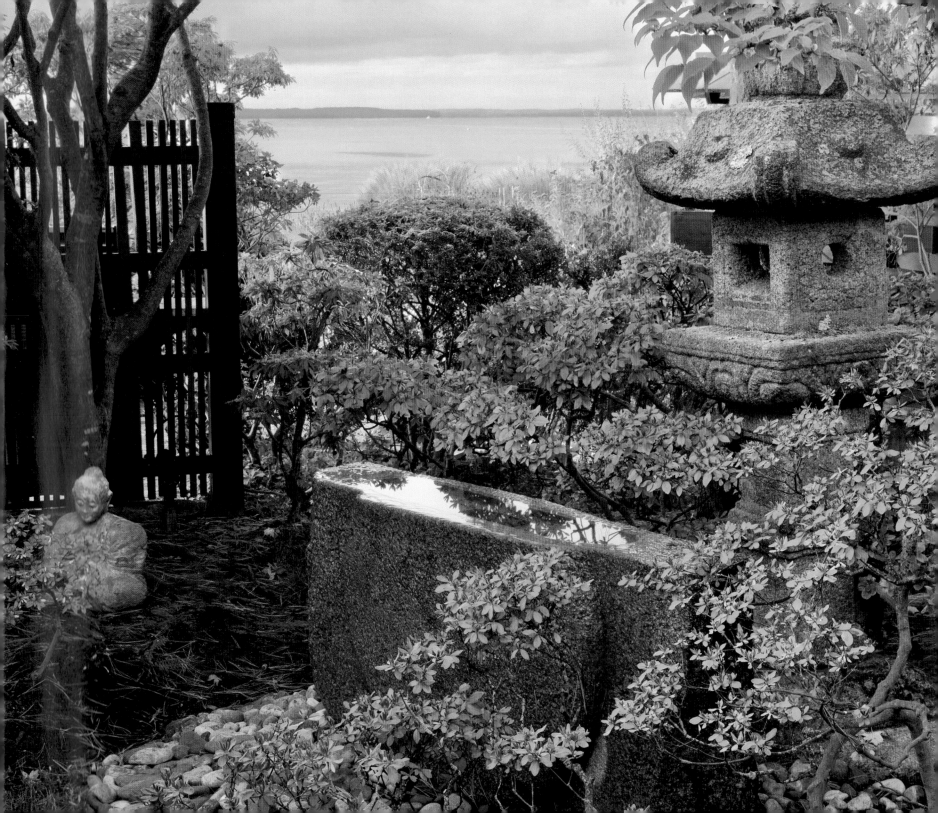

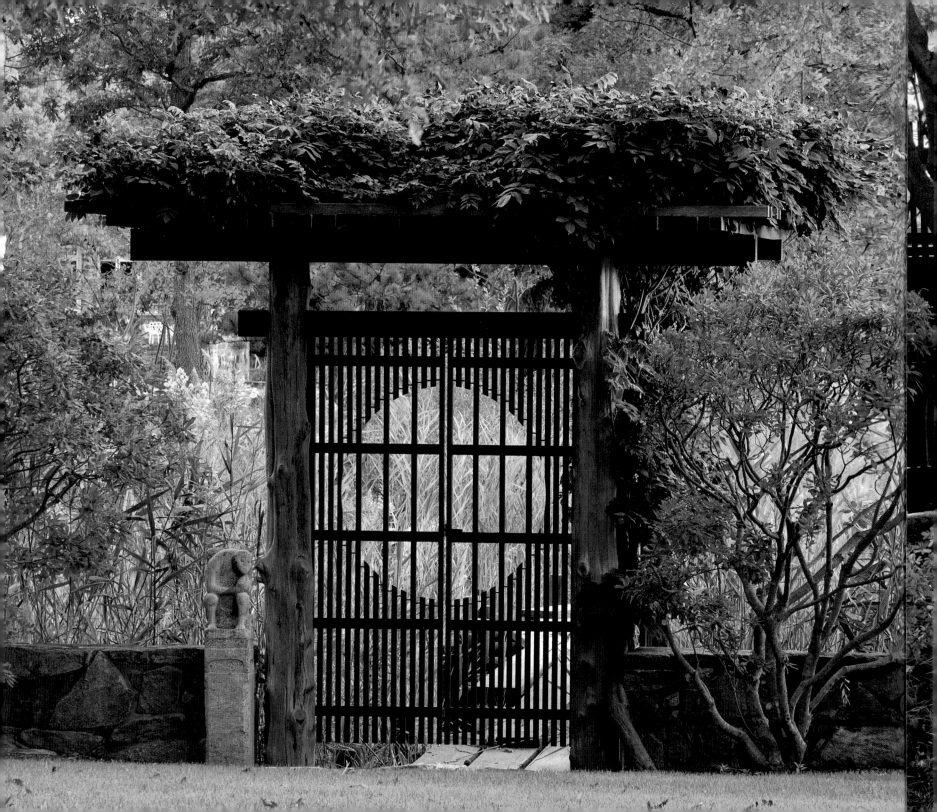

Visionary Landscapes

Japanese Garden Design in North America
The Work of Five Contemporary Masters

KENDALL H. BROWN
PHOTOGRAPHY BY DAVID COBB

TUTTLE Publishing

Tokyo | Rutland, Vermont | Singapore

contents

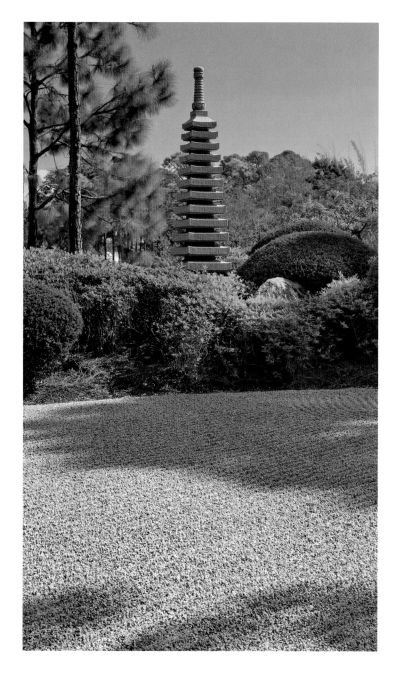

Opposite above Private residence, Washington, DC. *Left* Morikami Japanese Gardens, Delray Beach, FL. *Right* DeVos Japanese Garden, Grand Rapids, MI. *Far right* Tiger Glen Garden, Ithaca, NY.

TRADITIONS OF CHANGE:
JAPANESE-STYLE GARDENS TODAY

Gardens have flourished in Japan for fifteen centuries. Japanese gardens have been created around the world for only about 150 years, yet they are now more common outside Japan than in it. For non-Japanese, these gardens often exist as dreams of elsewhere and constructions of otherness. As microcosms of an idealized Japanese tradition, the landscapes can provide a compelling alternative to the banality of the here and now. Japanese gardens also serve as a kind of road home, a way of connecting with idealizations of nature that restore us mentally and physically. They are a cultural interpretation of nature refined into compelling and inspiring design forms transportable across time and space.

In the 21st century, Japanese gardens may well be considered a universal art. Like classical music, they are a set of forms and principles nurtured over time in a distinct place, then embraced and adapted so widely and deeply as to constitute an expressive language likely meaningful everywhere and available to anyone. Links with their birth culture, once strong, have become weaker as these garden styles accumulate identities and functions that may relate to Japan only tangentially. As such, it makes sense to call them Japanese-style gardens, acknowledging gardens based on adaptable values rather than gardens made in Japan or about Japan.

How and why have Japanese-style gardens grown into this remarkable, universal phenomenon? Beginning at world fairs in the 1870s in Europe and North America, Japanese entrepreneurs and officials built gardens as captivating settings for Japanese cultural and trade displays. At the same time, Euro-American tourists to Japan were filling their itineraries to the "flowery kingdom" with visits to gardens at temples, villas, restaurants and curio shops. Soon gardens became a kind of export commodity. Returning home, well-healed globetrotters commissioned their own Japanese garden. Aided by Japanese immigrants eager for work and abetted by Josiah Conder's popular primer, *Landscape Gardening in Japan* (1893), gardens graced grand country homes and middle-class yards. Entrepreneurs fashioned commercial tea gardens where people gathered for leisure. City fathers, anxious to promote civic culture and beauty, adorned their parks with Japanese gardens.

In the Cold War era after World War II, the desire to re-establish bonds with Japan instigated a fresh era of Western interest in Japanese culture. This led to the refashioning of Japanese gardens as symbols of sophisticated beauty and international cooperation. Whether naturalistic gardens that abjured the trappings

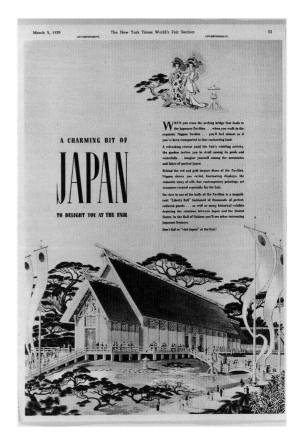

Left New York Times World's Fair Section, 1939. Courtesy of Nancy E. Green.
Above David Slawson's naturalistic Garden of Quiet Listening, created in 1976 at Carleton College, Northfield, MN, seeks to evoke a native place rather than a fantasy of Japan. It thrives under the thoughtful guidance of John Powell and a team of local gardeners.

JAPANESE GARDENS, FORT WAYNE, INDIANA

An example of pre-World War II exoticism, the Japanese Garden built in 1928 at Swinney Park, Fort Wayne, IN, featured a miniature Mt Fuji, waterfalls, a pond, a teahouse, Japanese iris and 25 kinds of peony. Photo courtesy of Kendall Brown.

of pre-war exoticism, or "dry landscape" stone gardens that spoke the new universal language of abstraction, Japanese-style gardens again enhanced homes and businesses. They also became the focus of public friendship gardens. Recognized as places rich with symbolism and life force, Japanese-style gardens were created at facilities—from schools and hospitals to prisons—linked with growth, rehabilitation and endurance. During the war, Japanese Americans incarcerated in Relocation Camps built high-quality gardens to bind the wounds of dislocation, isolation and group living while stressing the vibrant adaptability of Japanese culture.

Recreated and reimagined with impressive devotion, the phenomenon of the Japanese-style garden may appear as a kind of chronic modern madness. Given the expense of building and maintaining gardens that are living, and thus fugitive, art forms, and the audacity of transplanting the product of one culture in foreign soils, this devotion seems a kind of folly. Indeed, most

Japanese-style gardens created before World War II, and many after it, were abandoned in time. Yet, new gardens have been built without cessation, often reusing the "bones"—the stones, lanterns and plants—of defunct ones. The allure of gardens has outlived Japan crazes in crafts and waves of Japonisme in the arts. If history is a guide, gardens will abide when the fascination with *anime* (animation) and *manga* (comics) is long past.

The reasons for this Japanese garden madness are in part social and historical. With Japanese gardens signaling sophistication, the desire for status surely motivates their acquisition. Creating a Japanese garden also expresses a human desire to appropriate foreign things in a cultural masquerade that satisfies our inquisitiveness while cloaking the mundane facts of life. For North Americans and post-war Europeans, Japanese culture, manifested most holistically and immersively in gardens, offers a beguiling alternative to the old European order and opens up an unfamiliar perspective that presents the world afresh.

Japanese-style gardens also connect with specific historical contexts, for instance, with the American immigration themes of assimilation and alienation. For Americans in the late 19th and early 20th centuries, emboldened and burdened by manifest destiny, Japanese gardens proffered fantasy landscapes that both enhanced and questioned the great projects of subduing the land and its peoples, and then moving upward in cities premised on endless progress. Created across the vast continent, Japanese gardens fit into the pioneer narratives of taming nature by making it bountiful and beautiful and imprinting it with foreign cultures. Alternately, American Japanese gardens complicate the discourse of European civilization, which is resolutely practical and masculine, extending inexorably and inevitably westward.

More broadly, in the modern age of disenchantment, Japanese-style gardens offer re-enchantment. In an epoch of ideological fissures manifest in world wars, then international terrorism, and marked physically by dramatic, even cataclysmic technological development, Japanese-style gardens sustain belief in the redemptive power of nature and the reinventive potential of culture. With deep roots in nature and culture, gardens can nurture as well as liberate.

The social history of Japanese-style gardens opens itself to multiple critiques. As Western constructs of Japan, gardens form a rich chapter for the study of Orientalism. As projections of Japan's imagined uniqueness, they exemplify Japan's strategic self-Orientalizing. Japanese-style gardens also demonstrate the commodification of culture by the relentless culture industry. Gardens at

world fairs and sister-city projects show how art and history are deployed for political agendas.

Historical analyses clarify some basic motivations for and implications of Japanese-style gardens. Social factors also help explain why so many Westerners and some Japanese have been content with garish pastiches. However, the circumstances around gardens do not account for the deeper resonances of human experience in them. Historical investigation does not address the affective power that has made Japanese-style gardens so compelling to so many people in so many places for so many years. Although improbable luxuries in many ways, Japanese-style gardens can serve functions critical for our lives. Surely gardens are necessary follies.

People invest deeply in Japanese-style gardens because, when well designed and thoughtfully fostered, they have a rare capacity to move us, to hold us in awe,

to take us on a journey. Increasingly, the journey is not to Japan. Now, Japanese-style gardens function less as microcosms of Japan, repudiating the old world fair's function of imagined travel. Rather, they perform more effectively as Japanese-inspired microcosms of nature. The overtly Japanese features—moon bridges, cherry trees, lanterns—signal a cultural affiliation conveyed more profoundly in the ideas informing the arrangement and care of the plants, rocks and waterways. When present in moderation, signs of Japan, of foreignness, help us believe more deeply in a garden as an alternative order, a world complete in itself. This sense of leave-taking is symbolized and internalized by passage through the gate that often begins the physical garden journey. Letting go of the old, leaving the mundane, we enter new realities open to new possibilities. Losing ourselves we find ourselves.

New Japanese Garden Journeys

For Japanese-style gardens around the world, the 21st century signals a new era. The histories of gardens in Japan and Japanese-style gardens abroad are established, their links and differences clarified, so that huckster language proclaiming an authentic Japanese garden should induce a regretful cringe rather than wide-eyed admiration. Untethered from simply representing Japan by proxy, Japanese-style gardens are blooming in diverse ways. Models of hybridity, synthesis, adaptability and even sustainability, they are dynamic translations, not transplanted copies. Japanese-style gardens shift our perception of the originals and allow us to root ourselves more deeply in the world. Institutions and organizations in Japan, America and Europe debate and plan the evolving identities of gardens as an immersive living art. Gardens are places that we actively nurture. They are environments that nurture us individually and collectively. They are resonant sites for physical and mental healing, for repose and self-cultivation, for individual and social transformation.

In the books *Japanese-style Gardens of the Pacific West Coast* and *Quiet Beauty: The Japanese Gardens of North America*, my goal was to move from the appealing mystery of Japanese gardens to the accounts of the people who commissioned and created Japanese-style gardens. The first study, written with an air of academic melancholy, sought to shift the discourse from soft rhetoric about essences and authenticity to the hard ground of social, political and cultural circumstance. The second survey suggested how public gardens reflect

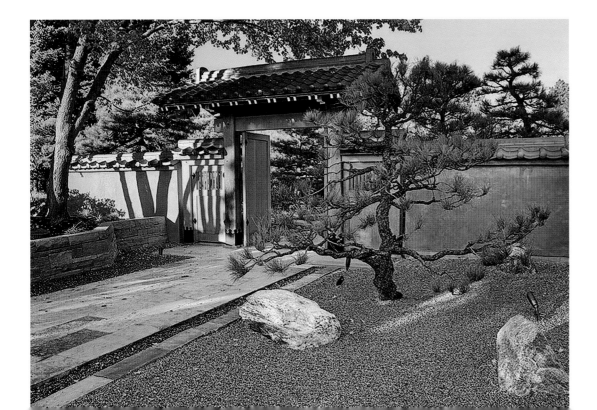

At the Denver Botanic Gardens' Garden of Pine Winds, the main gate was enlarged and relocated in 2012 as Sadafumi Uchiyama's master plan enhanced visitor flow. A signature ponderosa pine was also transplanted.

aspects of North American cultural relations with Japan over the past 120 years.

This book extends that trajectory to connect Japanese-style gardens with the minds and hearts of the people who create and utilize them now. For the author, this book rejects the historian's ostensibly objective presentation of the past to advocate for Japanese-style gardens as transformative spaces now and in the future.

Fujitarō Kubota's woodland stream-and-pond garden, created in 1961 at Bloedel Reserve, Bainbridge Island, WA, evokes both Japan and the Pacific Northwest.

It examines gardens built in the past two decades to reveal some of the most recent ideas about their design and function. It expands the scope from public gardens to gardens at homes and businesses to indicate how gardens impact us where we live and work. Because the pleasure and power of Japanese-style gardens bridge the intentions of their creators with the efforts and experiences of their users, I include mini-essays by garden builders on the gardens in Japan that inspired them and essays by patrons and users on the impact of gardens in their lives.

As with any art, Japanese-style gardens are diverse in form and fluid in meaning. They are shaped by such external factors as politics and economics as well as

field-specific agents like persuasive teachers and influential books. First, though, gardens are the product of the designers and builders who set their direction. The initial step in understanding contemporary Japanese-style gardens is to meet their makers.

This book examines the gardens of Hōichi Kurisu, Takeo Uesugi, David Slawson, Shin Abe and Marc Peter Keane. Based on the impact, quality and number of their gardens and publications over the past four decades, these five men have been among the leading designer-builders in North America—the region with the best-developed tradition of Japanese-style gardens. Subsequent chapters analyze the recent public, commercial and residential gardens of these five figures in light of their life stories and their design ideologies. These chapters are not authorized but are interpretations derived from their work, writing and interviews.

To stress the dynamism of Japanese-style gardens, most of the gardens here are newly made. As such, they have yet to accrue the patina of naturalness that comes with age. These young gardens suggest not only the edge of an evolving art form but signal the need for dutiful care and thoughtful use. Thus, this essay introduces some of the critical ways in which gardens grow physically and functionally. First, however, it sketches the diverse lineages of Japanese-style garden makers in North America to establish a context—the ground from which the five featured figures emerge.

The Topography of Garden Designers in North America

Most gardens built from 1885 through World War II were by men whose names and lives are obscure. Even when we know the biographies of first-generation immigrants (*issei*)—Tarō Ōtsuka (1869–?) in Chicago and Kinzuchi Fujii (1875–1957) in Southern

California—their attitudes remain opaque. In a few cases, documents reveal more. New York's famous Takeo Shiota (1881–1943) wrote that Japanese gardens are idealized landscapes holding spiritual connotations. By contrast, Shōgo Myaida (1897–1989), active from Florida to New York, and Seattle's Fujitarō Kubota (1879–1973) fashioned "American Japanese gardens" that deployed native plants, reflected local landscapes and embraced evolving functions.[1]

After World War II, a new generation of Japanese immigrants crossed the Pacific to make a living and a reputation by making gardens. Repeating the pre-war pattern, a few, like Nagao Sakurai (1896–1973) in San Francisco and Eijirō Nunokawa (1905–87) in Los Angeles, were university-trained garden builders. Others, like Kōichi Kawana (1930–90), took up garden making as part of an identity crafted in America. They worked beside and in competition with second-generation Japanese Americans (*nisei*). Many, like Henry Matsutani (1921–97) in San Francisco's East Bay, forged careers designing, building and maintaining Japanesque landscapes around Japan-inspired post-war ranch homes. Kaneji Dōmoto (1913–2002), heir to Oakland's Dōmoto Brothers Nursery, represents another *nisei* trajectory. Dōmoto studied physics at Stanford, then architecture with Frank Lloyd Wright, but unable to find work in those professions due to his heritage, he pursued a landscape career, making Japanese-style gardens in the suburbs of New York City and beyond.[2]

Even as Japanese American landscapers were adapting Japanese garden styles to fit the largely residential and commercial environments where they worked, in Japan garden builders were evolving new Japanese garden styles. Most notable was Jūki Iida (1889–1977), whose devotion to natural-style gardens is captured in Seattle's Washington Park Japanese Garden. His disciple, Kenzō Ogata (1912–88), known outside Japan for his gardens at the University of Hawai'i and

Far right Kōichi Kawana's dramatic, romantic and symbolic Garden of the Three Islands at the Chicago Botanic Garden features views of the unreachable Island of Eternal Happiness.

Right Kawana directs construction of the Garden of the Three Islands in 1980. Photo courtesy of Kris Jarantoski.

Brisbane Botanic Garden, fused the naturalistic garden with the concept of *kisei* (spirit force). Ogata taught that gardens could soothe the mind and body through emphasis on implicit and often indirect natural force that informs every part of the garden, from its composition and sound to the pruning of a single tree.

Ogata's ideas inspired and infused a generation of garden makers in Japan, and several who came to North America through the curator-in-residence program at the Portland Japanese Garden, initiated in 1968 by Takuma Tono (1891–1987). Chief among these pupils is Hōichi Kurisu, Portland's second curator, whose firm later employed several Ogata disciples. A product of that experience is Tōru Tanaka who, with five cohorts in the Ogata-kai, a group dedicated to continuing Ogata's legacy, created a public garden dedicated to him in Albuquerque. The naturalistic Ogata-based style refined in the Pacific Northwest is evident in the Cascades-themed Japanese garden at Central Washington University by Masayuki Mizuno, another former Portland curator.

From 1960 to 1990, an era of Japanese and American economic ascendance, Japanese masters created

important public and private gardens across North America. Katsuo Saitō (1893–1987), Kannosuke Mori (1894–1960), Ken Nakajima (1914–2000), Tansai (Taichiro) Sano (1897–1966), Kinsaku Nakane (1917–95), Yoshikuni Araki (1921–97), Tadashi Kubo (1922–90) and Makoto Nakamura made gardens that express each man's distinctive sensibility adapted to a new environment. Their impact is seen further in the work of Japanese pupils who emigrated to America, like Takeo Uesugi (Kubo, Nakamura) and Shin Abe (Nakane), and American students who trained briefly in Japan, including David Engel (Sano), Ron Herman (Kubo), Julie Messervy (Nakane) and David Slawson (Nakane). The next generation of Japanese garden builders currently active in North America includes Shirō

Nakane, Shunmyō Masuno and Takuhiro Yamada, among an expanding list.[3]

The Japanization of the North American landscape is also the result of regional and often remarkable Japanophile landscapers and landscape architects. For instance, Samuel Newsom (1899–1996), scion of a Bay Area nurseryman and architect, was so entranced by Japanese gardens that he studied in Japan from 1934 to 1939, wrote books based on the experience and created gardens around San Francisco. In contrast, landscape architect Ethelbert Furlong (1894–1993) never visited Japan but leveraged Japanese design to create modernist Japanese-style gardens from Manhattan to Maryland between 1935 and 1965. His minimalist Garden of One Hundred Stones, in consultation with Thomas Church, at a house in Orange, New Jersey, won ASLA and Pace Setter awards in 1949! The post-war re-embrace of Japan as part of Cold War Orientalism gave rise to a generation

To create a quiet garden retreat for a residence on Whidbey Island, WA, Sadafumi Uchiyama included a grove of bamboo and andromeda that opens to reveal a pond filled with water hyacinth and edged with Japanese kerria, sweet flag and Siberian iris.

whose exposure to Japan came during military service. Figures like John W. Catlin (1919–2008) in Los Angeles and Jack C. Miller (1924–2013), Philadelphia's "Moss Man," created gardens redolent of their interests and period styles. Current garden makers like Stephen Morrell and Chadine Gong near New York and San Francisco, respectively, demonstrate Japan's continued refraction in vernacular landscape.[4]

Other garden builders resist easy categorization. Although born to a family of nurserymen-landscapers, Sadafumi Uchiyama studied at the University of Illinois,

served in Japan's diplomatic corps then, inspired by regional environmental design, returned to Illinois for a Masters in Landscape Architecture, writing on Japanese garden history. After work in Kurisu's firm, Uchiyama set up his own business, then became curator at Portland Japanese Garden. His early gardens assert themselves with diplomatic restraint. At the Denver Botanic Garden, Uchiyama sensitively revised the flow in Kōichi Kawana's original pond-style stroll garden and added new gates as well as a tea garden. At the Sarah P. Duke Gardens, he realized curator Paul Jones' vision of a hillside waterfall-and-stream garden redolent of an abandoned warrior's villa. For a garden between the home and studio of a potter, Uchiyama's woodland stream creates a centered focus for the artisan at her wheel, a place to wander at leisure, and also captures distant views of Puget Sound and the Cascades.

Making Gardens Meaningful

The preceding paragraphs, which discussed gardens as solo productions, create the misleading impression that gardens, like paintings or sculptures, are made by heroic creators. In fact, most gardens are collaborative, and gardens of sufficient history are revised by the hands of time and by the hands of multiple makers and caregivers. Although writing about Buddhist practice, the famous priest and garden enthusiast Musō Soseki (1275–1351) wrote, "He who distinguishes between the garden and practice cannot be said to have found the way."[5]

For homeowners, whose garden connections are personal, there is no escaping the reality of gardens as process rather than product. The intimate, nuanced pleasures of evolving a garden are clearly seen in the hillside home of Stu and Jane Bowyer in Orinda, California, and in their writing about it (see next page). Implicit in their experience is a willingness to change unsuccessful features. Living with the garden, they

embrace its transformation through partnerships with diverse specialists.[6]

If working closely with talented garden builders and pruners is gratifying, then making a garden oneself is potentially even more rewarding. For this reason, and because people mistakenly think that gardens are easy to construct and maintain, there is a plethora of how-to books.[7] However, the numerous poor and abandoned self-made gardens suggests that Japanese-style gardens are best left to professionals intimately involved with

The hillside waterfall that flows from the street to the front of the Bowyer home in Orinda, CA, exemplifies how well-designed and maintained gardens provide places of dynamic tranquility for homeowners.

Creating Our Garden Home

In making a residential Japanese garden over forty years, our method is to find the best specialists and enlist their help. We have worked with four local masters: Mr Sato to make initial blueprints and create the dry lake; Henry Matsutani to design and build a waterfall; Dennis Makishima to shape trees and plantings; and Bill Castellan to place rocks. We read extensively about traditional gardens. When traveling to Japan as university professors, we always visit at least one major garden and stay in Japanese *ryokan* inns with gardens. After each visit, we incorporate new ideas.

Our obsession with creating and maintaining this piece of art is based on the indoor–outdoor flow of our relatively small hillside home. With two exceptions, each room opens to the garden. Minimalist décor allows our screened windows to frame the garden. Creative, beautiful and peaceful, the garden is a seamless part of being home. The garden wakes us and peacefully ends our day.

Our design principles are those of good art. Fascinated by how illusion transforms space and time, we borrow scenery from the distant hills to expand our space. The waterfall masks the view and sound of a public road a few feet away. We feel joy when we walk past the shaped black pines, under the *torii* gate, through the gradual unfolding of smaller gardens. It is a journey of discovery to walk to and from our home. The view is never the same.

We provide garden maintenance as we can, aided by people who love the garden. We are intimately involved in each decision and guided by the wisdom of the four masters. Our garden means life to us.

Jane and Stu Bowyer

the client. The rare exceptions reveal the great diligence required to create successful gardens as well as their profound benefits.

In 2000, artist Adel M. and her architect husband bought an historic house by modernist architect Harwell Harris. Built in 1942 on a hillside near downtown Los Angeles, the house was inspired by Japanese design in its open-floor plan, modular wooden construction and indoor–outdoor integration. After sensitively expanding the house to create several courtyards, they hired a landscape architect to redesign the backyard slope. Dissatisfied with a result inappropriate to both architecture and environment, they removed the garden and decided to create themselves a series of Japanese-style gardens based on their intimate knowledge of their site, vast reading, travel to Japan and design experience. Working with a staff of three gardeners, over a decade the self-taught couple have fashioned courtyard gardens, bamboo groves, a pond garden buffered by high, undulating hedges inspired by Kyoto's Shugakuin Villa, and a series of garden paths and rooms connecting the main house to a guest house below.

Masterfully creating areas of intimacy and broad spaces that frame and capture distant views, the owner-designers carefully balance texture and color, mixing meticulously pruned plants (podocarpus juniper,

miniature bay laurel and boxwoods) with a hardscape of gravel, stone, brick and slate. The hill garden is shaded by cork oak and California live oak as well as eucalyptus, with a mid-story of black pines, plum, toyon and agonis pruned in Japanese styles when possible. A perpetual work in progress, the garden is the proverbial labor of love, receiving significant investments of time, thought

The Garden of a Thousand Views at Bury Hospice in England is meant to be seen from inpatients' rooms, provide seating and allow intrepid visitors to experience surprise views by crossing its paths. Photo courtesy of Graham Hardman.

and money. Made—and remade—slowly, by multiple hands and under the direction of an artist and architect, the garden is a creative expression and immersive environment that comforts both body and mind.

The collaborative creativity of gardens may be broad. In the traditional model, a master works with a cohort of relatives and employees. In the contemporary case, professors of landscape architecture often utilize colleagues and students. Trade associations also produce gardens, with specialists often linking to complete a project in a distant place in a short time. For instance, in response to the 2011 disaster in Japan's Tōhoku region, the Garden Society of Japan (Nihon teien kyōkai) created a garden to commemorate the disaster and recovery.

Professionals from across Japan joined with garden students from Japan and abroad in a project where the spirit of human connection was as important as the resulting landscape.

Collective garden building thrives in Britain where members of the Japanese Garden Society (JGS), led by Graham Hardman and Robert Ketchell, began to build gardens in 2005. After making small courtyard gardens at public venues, from 2009 they have made gardens at hospices. In 2014, for example, eighteen JGS volunteers contributed 300 individual days to create a large garden at Bury Hospice. One volunteer, Ioan Davies, along with Hardman, wrote a *haiku*, later placed on a garden plaque, which encapsulates the project's value for both users and makers: "From tarmac and turf/a landscape, islands and seas:/solace for the soul."[8]

Collaborations can produce gardens and goodwill, but the joy of creation can overshadow the quotidian care required for a successful garden. Arguably, the commemorative function of many Japanese-style gardens celebrates completion but ignores maintenance. Moreover, emphasis on garden builders obscures the critical role of gardeners in a living art. To compound the problem, in Japan the hereditary system of garden makers-caretakers has eroded. In North America, first- and second-generation Japanese gardeners, men dedicated to a profession linked with cultural identity, have died off. Lacking adequate attention, gardens invariably decline.

To remedy this deterioration of gardens, gardening knowledge and systems of garden education, thoughtful gardeners are revising old paradigms of creation and maintenance and actively passing on what they know. Tomoki Katō, the eighth-generation head of Kyoto garden firm Ueyakatō and a PhD in garden history, has proposed the concept of fostering rather than maintaining. Fostering stresses the gardener's dynamic role in raising a garden as one raises a child from birth

In the linked garden rooms at the hillside M residence in Los Angeles, CA, the owners work with a team of three gardeners and volunteers to nurture a landscape that evokes Japanese principles while harmonizing with the local environment.

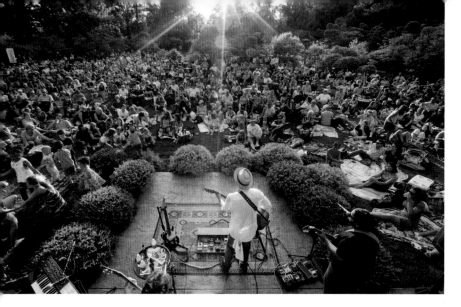

Miles Neilsen & the Rusted Hearts perform at the summer concert series at the Anderson Japanese Gardens, Rockford, IL. Photo by Nels Akerlund, courtesy of Anderson Japanese Gardens.

to adulthood and old age. Katō proposes that a garden is 40 percent the product of its being built and 60 percent the product of fostering. For Katō, the craftsman is a student learning constantly from gardens, from tradition, which itself is innovative, and from the team through shared sensibility and collective experience. Because gardens outlive their creators and initial caretakers, Katō's concept of fostering extends from nurturing gardens to cultivating generations of gardeners.[9]

Planned garden progression in North America is exemplified by David Slawson and John Powell. Recognizing that he was unable to care for the gardens he created, Slawson contacted Powell, a garden maker, pruning specialist and nurseryman, who had trained at Suzuki Zōen in Niigata and at the garden at the Adachi Museum of Art in Shimane. To adapt Slawson's gardens to shifting conditions, Powell had to grasp Slawson's ideas as well as local conditions. Realizing the relative brevity of his career, Powell trained local gardeners to support and eventually take over each garden's care. Likewise, public garden administrators, having paid large sums to create gardens, are now investing in the gardeners who evolve and foster the designer's vision.

Making Gardens for People

The rewards of fostering gardens extend beyond improving a garden's condition. Home gardeners have long known that gardens, while beautiful to look at, connect hands and heart. Garden pleasures include the tender exercise of pruning, the satisfaction of helping living things thrive and the sense of transcending oneself through intimacy with the earth. These basic benefits, along with the very real status accrued through gardens when used for social events, likely informed the creation of historic gardens in Japan, whether at the villas of aristocrats, the temple residences of monks or the estates of warriors. However, in the 20th century, when these places became tourist sites, open during business hours for viewing on a roped path or from a verandah, gardens were stripped of their core values. Like the modern museum model they emulate, gardens became historic sites for passive viewing. Gardens created for moon-viewing parties now close at dark, visitors must not touch—much less pluck—a sprig of flowers and reading a pamphlet's potted history replaces poetry writing as the expected literary activity.

In the half-century after World War II, Japanese-style gardens largely followed the passive contemplation model authorized by Kyoto gardens entrenched within Japan's tourist industry and cultural patrimony. The mode and mood of hushed reverence is often enhanced by a Japanese tea ceremony. It is broken only by the occasional Japanese festival that creates cultural cachet and weddings that bring cash. These joyous activities return human celebration, with music and drink, to gardens. They also extend visiting hours so that gardens soften in deepening shadows and are enriched by the scents of plants born on evening breezes.

In the great awakening now transforming public Japanese-style gardens, many are expanding their activities to open wide as places for diverse and dynamic engagement. Education, for instance, often extends beyond Japanese culture to art instruction for children and adults and special tours for the blind and those with special needs. Gardens now host art installations where art works intervene, often spectacularly, in the landscape. Some universities are planning gardens as part of mindfulness programs to liberate students from the mindlessness of cyber pop culture.

The myriad activities possible in gardens are exemplified by the Anderson Japanese Gardens in Rockford, Illinois. The once private garden has not only opened to the public but during a half-year season hosts an astounding array of social events: a summer festival, evening concerts, Friday night socials, a lecture series, tea ceremonies, children's classes and explorer tours, creative arts' workshops and health and wellness programs, including Early Onset Alzheimer walks, in addition to weddings and private parties. Most revealing of the Anderson's social mission is a program bringing patients from Rosecrance, an adolescent substance abuse treatment center, to the garden. There, they work with gardeners to foster the garden, an environment rich in biophilia and cultural markers of harmonious connection. The garden's size and complexity allow it to facilitate social communion and still stimulate solitary contemplation.

Arguably, this potential for direct engagement with nearby nature is what makes all gardens compelling. Because Japanese-style gardens function so persuasively as physical and philosophical microcosms, their pull is even stronger. The almost uncanny attraction of Japanese-style gardens is best revealed in the stories of the people who give their time and energy to work in them. The word "volunteer" conjures an image of a docent leading a group of students, the latter glad to be out of class and the former happy for an audience. Docent guides are important but volunteers accomplish more for gardens and for themselves. For example, they often do detailed but non-specialized tasks like weeding and deadheading blossoms that may seem tedious—like a form of punishment—for the paid worker but are therapeutic for the volunteer.

Most every volunteer program is full of talented people, working or retired, who "find themselves" in garden work. When Duke Gardens, next to a hospital, built a new Japanese garden, several retired medical staff volunteered. One, retired nurse Flora O'Brien, took on moss care as her specialty. Calmed by the focus of pulling leaves and pine needles from moss beds, after each session O'Brien composed a garden-based *haiku*. On September 17, 2015, she wrote: "In the quiet pool/ pine needles float/on the sky."[10] The poem, crystalizing one deep experience of nature, reveals the power of engagement with a garden to pull us fully into the moment, then transcend it.

In 2012, retired student advisor Martin McKellar began to volunteer in the new rooftop Japanese-style gardens at the University of Florida's Harn Museum. Intrigued by the patterns raked in the gravel of the dry garden, McKellar visited Japan to learn techniques and styles. His ground-up fascination with raking resulted in accidental discovery of its contemplative aspect. Feeling that he had been raking with his ego, McKellar started making patterns to "appease *kami*, not visitors." He next

pursued raking as a therapeutic activity for patients in the university hospital, working with the university's Arts in Medicine program inspired by the idea that "fine arts heal."[11]

The appeal of volunteering may also connect with identity, yet exceed it. In 2015, at age 78, Dawn Ishimaru Frazier began volunteering in the Storrier Stearns Japanese Garden. Created in Pasadena from 1935 to 1940, the large residential garden had been recently renovated and opened to the public. Raised in rural Reedley, California by a second-generation mother and an immigrant father who worked at local orchards, Frazier later lived in large houses in several cities. Widowed, relocated to an urban condo and finished volunteering at museums, she felt the need to touch, with gloveless hands, the living earth. Doing basic pruning and clean-up for four hours a week, Frazier enjoys the garden's quietude, time with other like-minded people and seeing things grow in a place that recalls her rural childhood and her parents' culture. "The critical thing," she says, "is connecting to soil, to plants . . . to something with a bigger, longer history."[12] The sway of gardens on volunteers speaks to kinds and

depths of engagement beyond the familiar binaries of labor and leisure, creation and consumption, private and public. Indeed, the transcendence of such boundaries is part of the appeal of giving oneself to a garden that is not one's own. Gardens make deep connections.

Gardens as Places of Wellness and Transformation

Writing the Foreword to David Engel's *Japanese Gardens For Today*, modernist architect Richard Neutra calls Japanese gardens "humanized naturalism," citing their ability to please "the humble, the modest, and the rich." Neutra attributes this deep satisfaction to the "multi-sensorial appeal of the sounds, odors, and colors of nature, the thermal variations of shade, sunlight, and air movements" in Japanese gardens. He imagines "happy endocrine discharges and pleasant associations" in the body of the strolling visitor, and "vital, vibrating functions of subtle life processes" for the viewer in repose.[13]

Neutra's assumption of positive physical responses to Japanese gardens is born out in studies by Eijirō Fujii

Martin McKellar rakes patterns in the dry rooftop garden at the Harn Museum, Gainesville, FL. There he leads a team of volunteers who care for the garden and creatively connect it with patients in a nearby hospital. Photo courtesy of Martin McKellar.

and his students on the psycho-physiological effects of Japanese gardens. Using electroencephalograms and infrared spectroscopy to measure brain activity as well as eye movement analysis, Fujii charted reactions to tree arrangements and pruning styles, finding responses to Japanese garden forms more calming that those in symmetrical gardens. The research of his students Seiko Gotō and Minkai Sun shows that Japanese gardens have palliative and perhaps healing effects among patients with Alzheimer's disease and dementia by, at the very least, reducing stress.[14]

The positive psycho-physiological response to Japanese gardens suggests that they constitute the kind of optimal environment innately preferred by humans because they facilitate physical and mental wellbeing. Rachel and Stephen Kaplan famously posited that humans prefer open yet spatially rich places that include water, diverse plants and discrete signs of human habitation. Structurally, such places feature moderate complexity, with visual coherence at a glance, legibility if one imagines action there, and mystery—the promise that one could learn more. This last quality is best realized in compositions where the foreground is seen but "part of the landscape known to be present is nevertheless concealed."[15]

The Kaplans proposed that such landscapes induce involuntary attention that is restorative. Restorative environments are predicated on the sense of "being away," inhabiting a place where one integrates with something different from the norm. This environment must be a "whole other world," with a scope and connectedness as well as coherence that makes even small spaces seem large conceptually. Critical is fascination, the pleasurable stimulus to reflective engagement found in dramatic things like waterfalls but more often in the soft fascination of the play of light and shadow or the texture of leaves. Last is a sense of belonging based on accord between environmental

patterns and the human actions required to navigate them. In sum, restorative spaces produce the satisfaction of union with something older and greater than oneself that William James described as "the belief that there is an unseen order, and that our supreme good lies in harmoniously adjusting ourselves thereto."[16]

The Kaplans' analyses of optimal environments and restorative landscapes could well describe many types of Japanese pond-style gardens and explain their deep appeal.[17] Because Japanese-style gardens have long been deployed as potent symbols of an idealized Japan, only recently are they being embraced as microcosms of idealized nature able to transform our lives. This capacity motivates Ketchell and Hardman's hospice gardens in Britain and Martin Mosko's contemplative gardens in Colorado.[18] It also defines most gardens discussed in the following chapters.

The discovery of Japanese-style gardens as spaces of psychological transformation is generating new activities in public gardens. Under the banner "The Year of the Healing Garden," in 2012 the Portland Japanese Garden focused its lectures, demonstrations and art displays on the garden as a healing space, exploring links between Japanese gardens as models of biophilia and health. To see if engaged garden walks could decrease depression, loneliness and fear and encourage happiness, in 2006 Ruth McCaffrey of the School of Nursing at Florida Atlantic University began developing therapeutic walks in the large stroll garden at the Morikami Museum and Japanese Gardens in Delray Beach, Florida.

The program was initiated in response to letters from garden visitors stating its profound impact, a growing body of literature on how gardens improve the moods of hospital patients, and evidence that exercise itself is therapeutic. Combining these facts with reminiscence or reflective therapy, premised on the idea that reflection can ease depression, McCaffrey's team tested several kinds of guided and unguided walks. These

experiments eventually produced the Stroll for Well Being: A Reflective Garden Walk that combines individual strolls on twelve themed garden journeys (awareness, connection, trust, forgiveness and so on), stops at six specified spots (including a gate, pavilion and zig-zag bridge), reading a descriptive paragraph connecting a theme (gratitude, reflection, etc.) with each of the stops, and then the journaling of responses. Participants met with a facilitator before and after the walks over several months. Based on answers to standard questions measuring depression, participants significantly lowered their depression levels. In responses to broad questions by the facilitator and journal entries, participants signaled four positive experiences: feelings of release based on being away from stress inducers; appreciation of nature's beauty; depth added by the short texts to the garden experience; and gratitude both for their lives and nature.[19]

At Chiba University, a subject's brainwaves are measured while viewing a bonsai pruned in the Japanese open-branch method. Photo courtesy of Mohamed El Sadek, Eijirō Fujii and Sun Minkai.

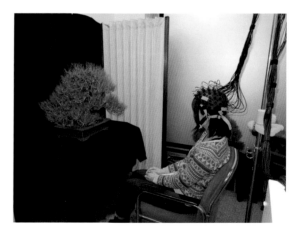

Epilogue: Gardens of Vision

When utilized by people in dynamic, diverse and deeply felt ways, Japanese-style gardens resonate in spirit—though not always specific function—with pre-modern gardens in Japan. This reconnection of Japanese-style gardens with profound experience is brought about by thoughtful actions, yet it is based on qualities within gardens. Thus, gardens created as shallow pastiches of "Japanesey" features fail as restorative environments. Even as they signal the status of Japanese gardens, they diminish their value as a universal art form. Required instead is design that is sensitive to the principles of Japanese gardens and to the practices of modern life, be they communal celebration, therapeutic activity or individual introspection.

The following chapters explore gardens by Hōichi Kurisu, Takeo Uesugi, David Slawson, Shin Abe and Marc Peter Keane, noting how each creator inflects and interprets Japanese garden ideals. Woven across the chapters are qualities that describe Japanese-style gardens and define them as restorative environments. These traits include dynamic balance by which gardens harmonize diverse energies. The balance is found in the types and arrangements of stones and plants, in the real or implied flow of water and in the smoothly supple energy of koi fish in ponds. By connecting the deeper rhythms of our bodies with natural forms, gardens create a resonance between the individual and the cosmic. Because gardens are enclosed, explicitly or implicitly, they offer safety. Confined and microcosmic, gardens open up boundless imaginary vistas. They also trans-mediate sensory experience. Sight, smell, texture and, most of all, sound (a stream's murmur, a waterfall's buzz) merge to create a fully integrated realm that transports the visitor to an alternative reality.[20] Most basic in Japanese-style gardens are spatial relations (*ma*), where space is an evocative interval—a pregnant pause—indicating a way of being in the world premised on intimate and thoughtful relationships.

The modernist landscape architect and theorist Garrett Eckbo (1910–2000) was ambivalent about Japanese gardens in the modern world, given Westerners' "shallow curiosity and blind imitation." However, Eckbo calls Japanese gardens "probably the most highly refined and completely developed garden conception our world culture has known," citing their "sensitive expression of the specific natural character of material" wedded to its "larger human conception." Even as Eckbo dismisses the "mystic obscurantism" and "Ivory Tower" escapism of Japanese gardens and activities like tea ceremony, he conceptualizes them as spaces "for withdrawal, repose, contemplation and ceremony," and as places where one seeks "order in a disorderly world."[21]

Entering a garden, being made aware of it and by it, we contemplate. Meaning "to view thoughtfully" and "to have as a purpose," "contemplate" derives from the Latin for a way of being in a sacred enclosure. In sum, contemplation is a special kind of vision activated by powerful places. Japanese-style gardens function most profoundly as gardens of a vision that is both outward and inward. This vision takes in the multisensory patterns of nature as designed and fostered by humans. It is also retrospective and introspective, situating itself in space and in time so that each piece of information is filtered through memories and associations.[22]

Japanese-style gardens call upon nature and on traditions of understanding and accessing it. But in the most creative and compelling gardens, this appropriation of the past is not a vain attempt to regain a lost ideal. Rather, it is a kind of epiphanic vision that places tradition as an inherent potential. In this sense, because Japanese-style gardens exist nowhere and everywhere, they can be accessed through a kind of poetic vision. With it, they slip the bonds of history to live in an eternal present.[23]

Lanterns pull the eye through space and provide contrast in texture, shape and tone with the plant palette at the M residence in Los Angeles, CA.

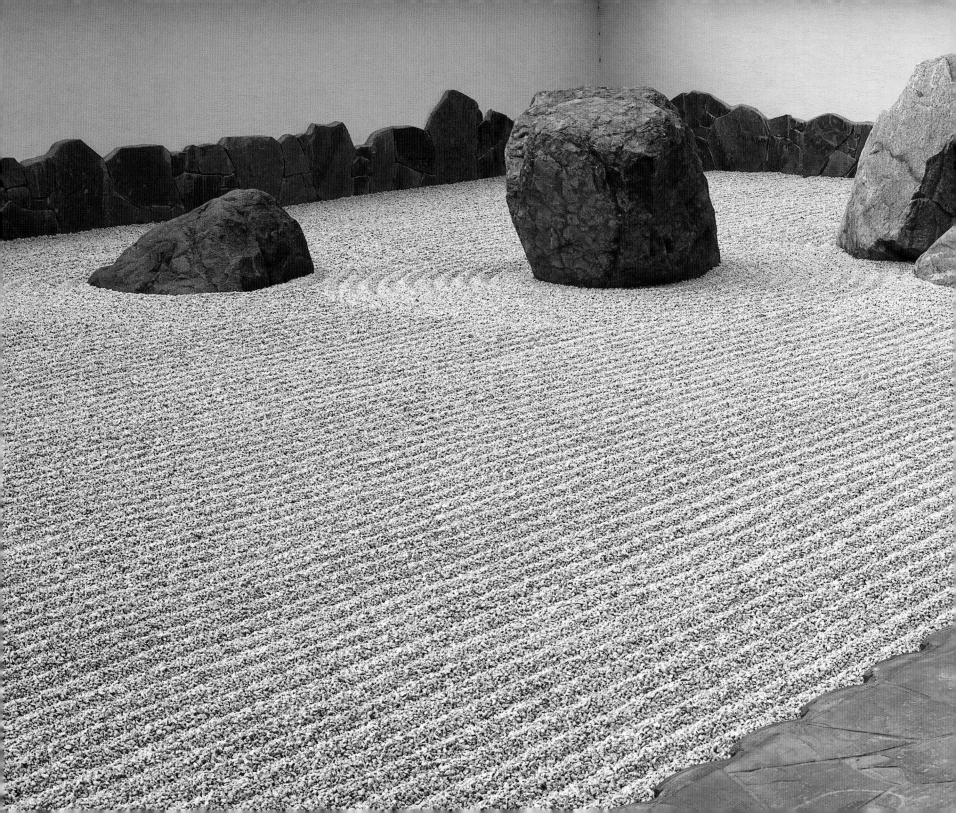

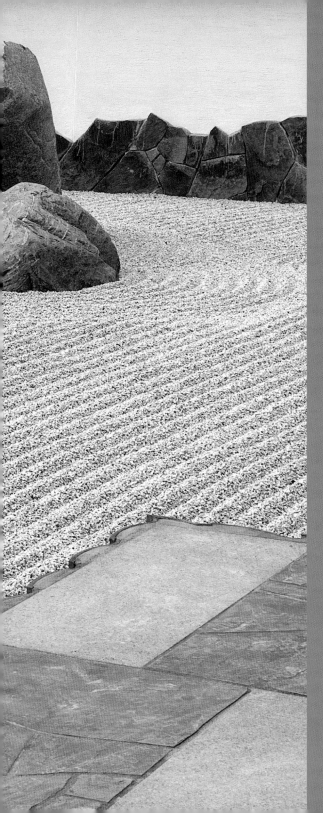

Gardens of Vision—Lives of Insight:
The Healing Worlds of Hōichi Kurisu

Gazing at Hōichi Kurisu's most successful gardens reveals a subtle sensitivity to material and its arrangement. Walking in them is to discover space as a transformative experience. Observing the website or promotional materials of Kurisu International, one encounters a garden as a humanistic social agent intended to restore "mental, physical and spiritual equilibrium."

Kurisu's ideal of uniting "people, place, and purpose" derives from long experience designing, building and fostering gardens. It is also born from the early experience of the physical deprivation in wartime Japan and the spiritual deficiency of post-war America. Kurisu's practice is premised on the belief that intimate connection with nature—through its sights, sounds, textures and fragrances, as well as memories—can ameliorate the anxiety and ennui caused by the regimented materialism of an affluent, system-oriented society. This balance of large vision with fine design informs his most successful public, commercial and residential gardens.

Kurisu's commitment to gardens that can heal the world makes him a leader in the movement to change Japanese-style gardens into places of individual and social transformation. The first half of his company's former motto, "gardens of vision—lives of insight," inspired the title of this book. Kurisu's vision, and its implementation, evolved dramatically in the last part of his career. As this book was written, Kurisu was imagining gardens that could take people, including prisoners in an Oregon correctional facility, on journeys of self-discovery. His short essay on page 23 attests to the spirit of wonder that Kurisu seeks to create in his gardens.

A Life in Gardens

Born in 1939, Hōichi Kurisu was raised in Tsunami, a small town near Hiroshima. He was reared largely by grandparents who returned to Japan in the 1920s after two decades in California. His early memories include desperate destruction and food scarcity at the end of World War II, followed by the almost magical return of hope as plants, and sustenance, sprouted in the family garden and forest. In 1962, after study at Waseda University, Kurisu went to California to join his father who had bounced between America and Japan. In Los Angeles, Kurisu assisted his father and stepbrothers in a landscaping installation and maintenance business. The experience impressed upon him the possibilities of spreading Japanese culture outside Japan, the ability to have a successful business and the unhappiness and emptiness that defined the lives of too many Americans despite their material wealth.

Kurisu returned to Japan in 1964 to study at the Tokyo University of Agriculture. There, Professor Kenzō Ogata's emphases on the experience of space and *kisei* (spirit force) in a garden, and the resulting joy, contrasted profoundly with the empty forms of the small quasi-Japanese gardens Kurisu had seen in Southern California. In 1968, when Takuma Tono (1891–1987), another professor at the university, offered him a chance to take the position of curator at his newly created Japanese Garden in Portland, Kurisu jumped at the opportunity. He served two two-year terms, refining the raw garden. In 1972, Kurisu established his own design-build-maintain firm, Kurisu International, serving primarily residential clients in Portland. His early design philosophy was to integrate house with

Above Hōichi Kurisu creates gardens to immerse people in the curative harmony of the natural world. Photo courtesy of Kurisu, LLC.
Right Kurisu mastered naturalistic water features at The Quintet condominium complex in Portland, OR.
Opposite The abstract *kōgetsudai* (moon-facing platform) at Kyoto's Temple of the Silver Pavilion epitomizes the potential for creativity in Japanese gardens.

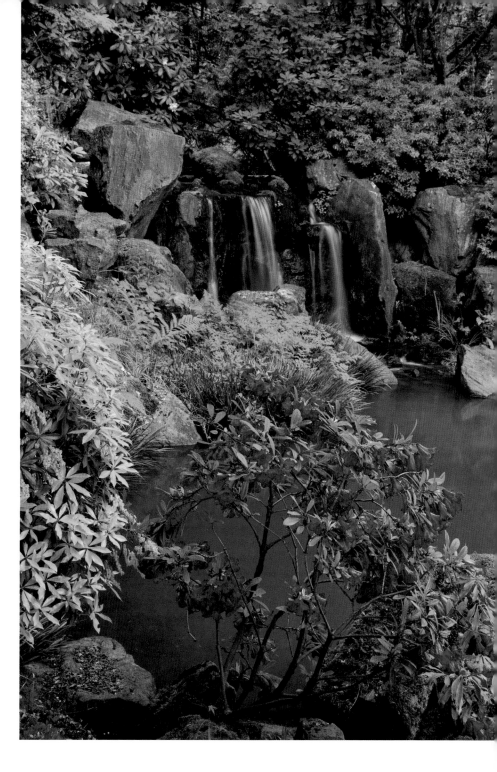

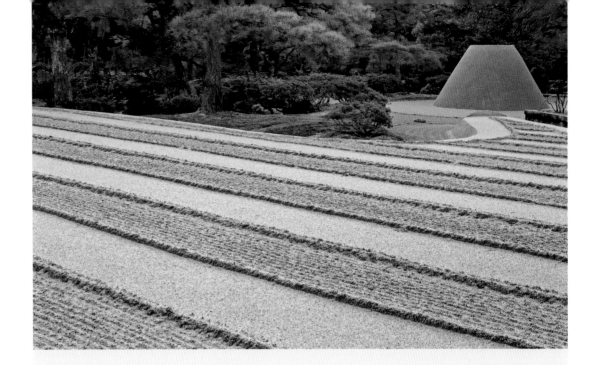

garden to connect the residents with natural space, bringing non-material value into their lives.

Although clients often did not understand Kurisu's admonition that an authentic Japanese garden resides in the spirit, not the surface features, his business flourished and he expanded to create and care for dozens of commercial properties. By the mid-1990s, Kurisu International had eighty employees and its own nursery. It had also helped train several men who would create their own garden businesses. Despite making some powerful landscapes, including the magnificent, seemingly natural cascade at The Quintet condo complex in Portland, and feeling that he had flexibility of thought as a Japanese working in the US, Kurisu created only one major public Japanese garden in the 20th century.[1]

In 1978, John Anderson, who had been mesmerized by a visit to the Portland Japanese Garden, hired Kurisu to take over the pond garden behind his house in Rockford, Illinois. Laboring on this project for part of almost every year for four decades, Kurisu made the rapidly expanding Anderson garden his laboratory. Working with a devoted patron, Kurisu created a variety of gardens linked physically by sinuous paths and conceptually by water. With a magnificent waterfall, gurgling brook, limpid stream, two large ponds and a dry pond of raked sand, flowing water instigates movement and energizes space. Present yet fluid, water is Kurisu's most powerful expression of *kisei*.

Feeling that ideas, not history, drive creation and that designers should have the heart to innovate, Kurisu started the 21st century with a project at the Morikami Museum and Japanese Gardens at Delray Beach. The necessity of using Florida-adapted, not Japanese, plants in a garden ringing a 7-acre pond challenged Kurisu. In response, he dramatically juxtaposes six adaptations of historical styles. These garden rooms open along a path that creates a sense of anticipation, discovery and repose in its mix of transitional and discrete spaces.[2] More

Timeless Essence: Design for the Inner Senses

There are many excellent gardens but only a few that over the years continue to resonate in my mind. For me, one of them is Ginkakuji, the Silver Pavilion, in Kyoto. Its atmosphere surpasses every other garden. It is not so much the technical design that amazes me but the keen artistic sense and what emerges from it. The inspiration of the garden creator must have been profound as Ginkakuji is an experience that transcends its own physical form. What you feel is beyond what is visible. I am amazed that even despite the terrible Ōnin wars of the 1470s (1467–77), the shogun Ashikaga Yoshimasa managed to create something so tranquil that affects human sense so powerfully.

I can imagine someone sitting alone in the garden at night—a full moon shining on the *kōgetsudai* (moon-facing platform)—looking at this garden set at the base of a mountain. I cannot imagine that it is real. It's beyond anything else other gardens have tried to achieve. Who would create this kind of landscape?

The garden at Murin'an affects me in an entirely different way than does the Silver Pavilion. This garden, created at the dawn of modern Japan by the great Ogawa Jihei (aka Ueji), lifted the concept of Japanese gardens out of the box. It created open space. In a gentle way, Murin'an merged Japanese and Western cultures. For that era, this was revolutionary.

Hōichi Kurisu

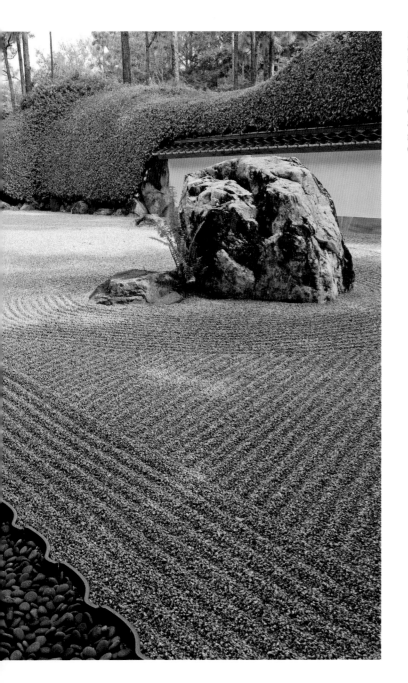

Left Kurisu first created a garden as a space for mindfulness in 2001 in the Late Karesansui Garden at the Morikami Museum and Japanese Gardens in Delray Beach, FL. *Opposite* The Morikami's gate demarcates a transition in space and interval in time, signaling the garden experience as a journey of external and internal discovery.

importantly, Kurisu takes visitors on a journey over bridges into forests of singing bamboo, offering expansive vistas then restricting views, and providing bounded gardens of contemplation and elevated pavilions offering inspiration. In his mission statement of January 2001, Kurisu explains his vision of the garden visitor "little by little laying aside the chaos of a troubled world and gradually, gently nurturing the capacity within to hear a more harmonious, universal rhythm . . . exchanging burden, boredom, and despair with renewal, inspiration, and hope"

Kurisu has pursued restorative gardens in several ways. In the Healing Garden at the Rosecrance adolescent substance abuse facility in Rockford, Kurisu adapts the bridges (representing serenity and strength), bell tower (whose tones express balance) and winding path (conveying life's passage)—elements of a pond-style Japanese garden—to create a journey of self-reflection where water, "the lifeblood of the garden," moves from a rushing waterfall to the stillness of a pond.[3]

Elsewhere, Kurisu extends restoration to encompass repair of the land. This environmental remediation is best witnessed in his Talking Water Garden in Albany, Oregon, where bridges and paths, as in a pond-style stroll garden, lead around a 50-acre site. There, waterfalls (from one to 15 feet) and weirs mix and aerate 12 million gallons of water each day, stimulate plant growth and provide a symphony of soothing sounds. In this project, which is loosely inspired by Japanese garden ideas, Kurisu has created a natural water treatment process and a place of beauty on a quasi-industrial site along the Willamette River.

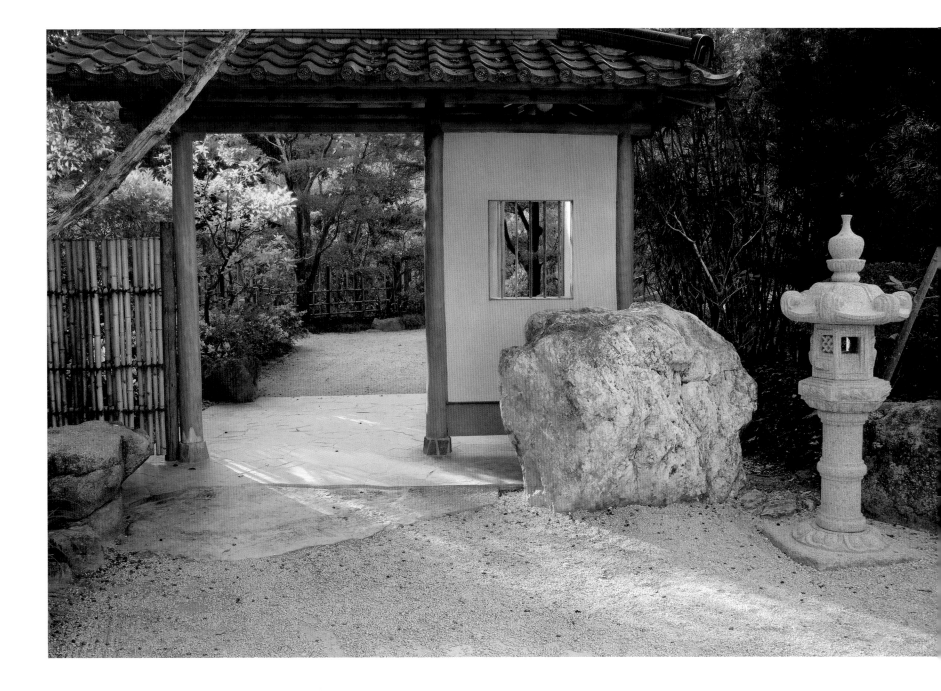

Repairing the World:
The Samaritan Lebanon Community Hospital Garden

A rivulet bordered by California sword fern and grassy leaved sweet flag falls gently into the hospital garden pond.

Eager to breath life into a fading institution and town, in 2004 the Lebanon Community Hospital Foundation launched a campaign to fund a health careers' education and training center at the 25-bed hospital in rural Oregon. A trustee proposed the benefits of a Kurisu garden to bring the healing power of an 11,000-square foot Japanese-style garden into the hospital. The classrooms and maternity ward look into a woodland garden with a simple pavilion. Patients in the chemo-therapy infusion center get treatment while gazing at rivulets descending a stone-clad hillock and the gentle rhythms of koi swimming in the pond at its base. Visitors, employees and patients walking the long halls gaze into the garden, as do customers at the hospital café, Garden Grounds.

The garden's "remedy in green" and "infusion of serenity" extends throughout the hospital. The hospital's ArtsCare program, dedicated to "fostering healing through the arts," has placed garden photos by patients and professionals and Japanese nature-themed art on the walls, a tree-motif donor wall and strings of origami

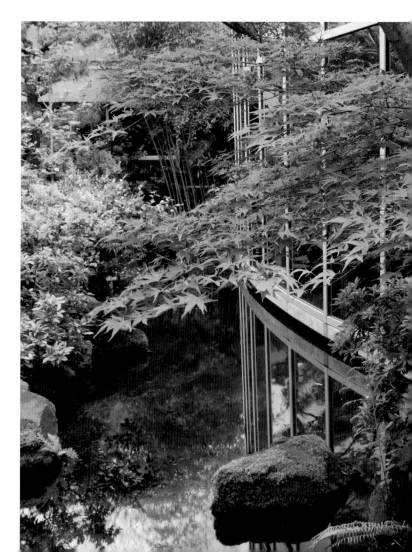

Left Hospital staff, visitors and patients can enjoy the densely planted courtyard garden from benches along a gentle path.

Left Outside the chemotherapy infusion center, a light canopy of Japanese maples and bamboo shades the pond, its meeting with the structure softened by western azalea and Japanese pieris.

Right The quiet hospital garden is contrasted with the excitement of the neighboring convention center garden with its dramatic mix of rushing falls and colorful shrubs below towering trees.

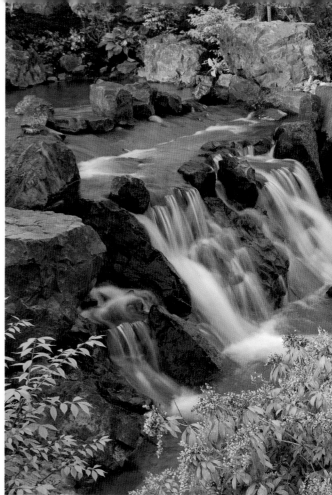

Left Iris, planted sparsely in the large pond at the Health Science Campus, add a structural element consistent with the pavilion posts—both actual and reflected.

Below A woodland scene under a Japanese maple shows thriving botanic life with western azalea, California and western swordfern, sweet flag and goldflame Japanese spirea.

cranes floating from ceilings. As Foundation Director Betty Koehn describes on page 31, the garden has transformed the mental wellbeing of hospital patients and caregivers. It also has revived the economic health of Lebanon, a once-thriving mill town that lost its mills. The garden-adjacent care has attracted out-of-area patients to the facility and drawn doctors from afar.

Impressed with the physical and economic environment, administrators at the Western University of Health Sciences in Pomona, California, decided to build their new osteopathic medical school across from Samaritan. This construction was followed by the Veterans' Administration erecting a 154-bed residence and, in 2014, Samaritan creating a hotel and conference facility centering on a 1-acre waterfall-fed pond garden lavishly

installed after a 2.5 million dollar campaign. The new garden, featuring a series of dramatic waterfalls feeding a tranquil pond, is traversed by a winding path, viewed from pavilions and spied from the adjacent Boulder Falls Inn. Retail and residential projects are being added in dramatic testimony to the power of sensitively made Japanese-style gardens to assuage the infirm, engage medical professionals, inspire investors and thereby heal a community.[4]

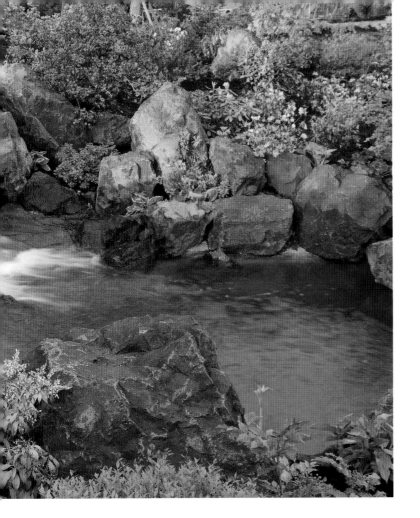

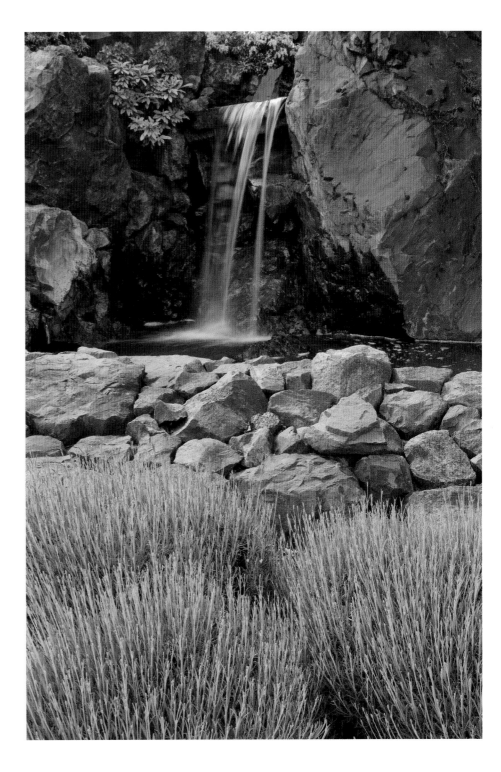

Above In spring, the area around the waterfall explodes in color with hosta, burning bush, Kurume and western azalea, American and glacier rhododendron, goldflame spirea and mountain fire pieris. It serves as a focal point for guests at the buildings surrounding the large pond-style stroll garden.

Right This waterfall, using natural run-off from the hillside, is composed of locally quarried Columbia basalt. The massive stones, including a 20-ton boulder at right, are softened above with Japanese pieris and rhododendron and absorbed below by a bed of lavender.

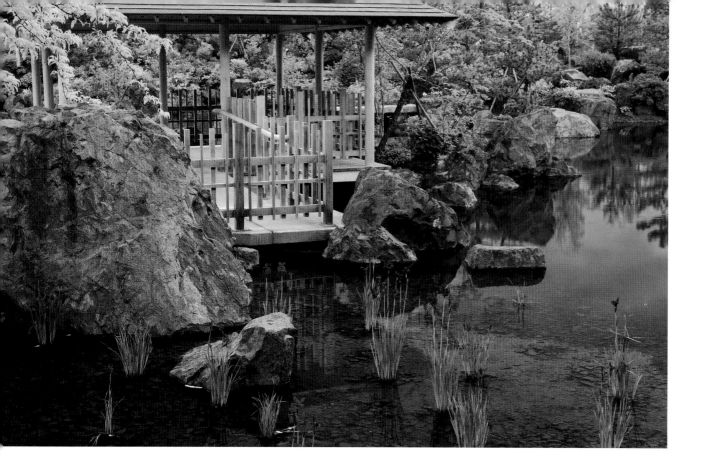

Below right The path in the hospital garden leads to a covered rest shelter where strollers can feel completely removed from the medical center that surrounds them.
Below Koi bring tranquil energy and colorful elegance into both the small pond by the chemotherapy infusion center and the lake that links the convention center and hotel.

Above A viewing pavilion creates a complex transition from the large deck to the expansive pond at the convention center garden. Smaller stones in the background force the perspective, making the space seem larger.
Right Kurisu evokes the spirit of the Cascades with nest spruce and crimson rhododendron, and the opulence of Japanese *daimyō* stroll gardens with artfully arranged boulders flanking a stone bridge.

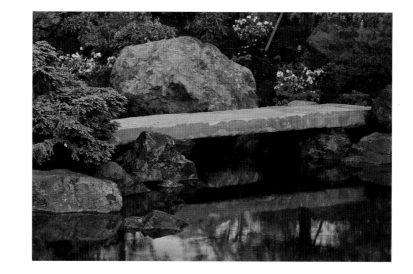

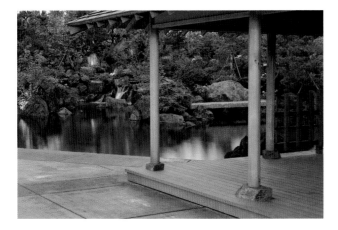

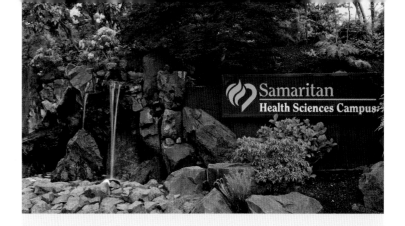

Left The crisp edges and matt tones of a wooden pavilion frame the organic forms and stippled colors of the landscape. The reflective water mediates the two realms so the garden is a symphony of harmoniously integrated elements.

Right Between the hospital and the Boulder Falls Center complex flanking Santiam Highway, a man-made hillside with waterfall announces the thriving Samaritan complex.

Working at Hōichi Kurisu's Hospital Garden

As Director of the Lebanon Community Hospital Foundation and a hospital employee, it has been an honor to engage donors in funding the construction of Hōichi Kurisu's Japanese-style healing garden within a central space of our facility. Because a Japanese garden at a hospital was a new concept in our rural area of Lebanon, Oregon, initially I had no idea how the garden would benefit our hospital and community. I could imagine it would be a beautiful space for patients, visitors and employees.

Now that the garden has been here for over a decade, there are so many heartfelt stories to tell. I will never forget one critically ill patient who kept asking to go into the garden. When he was well enough he entered it, and later told me that visiting the garden helped him to decide to not give up, to fight his disease. He recovered to live eleven more years. Among staff, I recall how a nurse manager sent employees to the garden one by one following a tragic medical incident. After experiencing solitude in the garden, employees were able to return to work revitalized.

Personally, it is a privilege to walk down the long hallway that spans the length of the garden and look out at nature every day. Watching the changing of the seasons always inspires me! The garden has transformed how I process things. We all need the calming presence of nature to clear and invigorate our minds.

Betty Koehn

Eden on the Fourteenth Floor:
A Garden Grows in Downtown Chicago

The capacity of Japanese-style gardens to connect us with the earth and to a living tradition has led to their creation in many unusual places. In pre-war Manhattan, rooftop Japanese gardens topped the Ritz and Astor hotels and the RCA Building. In contrast to that high-wire exotica, Kurisu's garden for a penthouse condominium at the Contemporaine Building in Chicago performs as does any terrestrial creation. A marvel of engineering, with electrically heated 10-inch-deep planting beds as well as real and cast stones, the garden fashioned by Kurisu may be unnatural in its location but is natural in appearance and nurturing in its impact on residents.

In 2005, a couple seeking an urban sanctuary at their neo-modernist high-rise condo in Chicago's River North district hired Kurisu to create a series of Japanese garden rooms on the 3,000-square foot patio. Despite the concrete and aluminum building materials and the location among Chicago's famous towers, the bounded space framed by the overhanging roof resembles a

Japanese courtyard mediated by a verandah beneath eaves. Kurisu uses maples and pines to partially screen the garden, both creating intimacy in the garden and allowing limited glimpses and spectacular vistas of the surroundings. A waterfall in one corner brings the sound and movement of water to the garden and feeds the shallow pond.

One accesses the garden from the condo's entry, where a small waterfall and stone floor lead out to a *nobedan* paved path, across stepping stones over the pond and then into the garden's depths. Not only do plants divide the main garden into a series of linked but sequestered spaces, a second garden accessed through the living room adds spatial complexity and intrigue. The vertical stones are analogues for the broad-shouldered towers, while the water (or just elegant black beach

Opposite In a smaller garden on the condo's north side, the rhythm among the cast fiberglass stones parallels the office towers of Chicago's Loop.

Left The shallow watercourse, necessitated by the balcony site, reflects both sky and adjacent windows so that interior and exterior dissolve and merge.

stones when the water is drained in the winter) links the garden to adjacent Lake Michigan.

The power of this garden in the sky is witnessed by its hold on its second owner. When newly divorced and well-traveled investment banker John Leonard looked for a residence in central Chicago, he wanted somewhere he could be grounded and recall his boyhood in the woods of Wisconsin. On first seeing the garden condo, he could not imagine not living there surrounded by the city and by nature, invited to explore while being comforted. The garden transports the four seasons into the heart of the city. It also provides a place for Leonard to work with his hands, even transplanting a few shrubs long tended by his late father. The garden is conducive to introspection, so that no matter how awful the workday Leonard cherishes his return home where balance returns in the garden's invitation to mindfulness. Although he once felt he would leave Chicago, Leonard feels bonded to the garden, needing to take care of it for the next generation.[5]

Left Kurisu's masterful design provides a sense of intimacy and refuge while encouraging deep prospect into dramatic borrowed scenes of skyscrapers.

Right Viewed from the path paralleling the windows, a cast rock, stone lantern and Scotch pine set among a thicket of tree peony, azalea, rhododendron, serviceberry and pachysandra, screen off the side of the building.

Above During warm months when the water runs, the small cataract focuses auditory attention on the gentle sound of water rather than the roar rising from the ocean of traffic below.

Right A range of cast stones and Scotch pines provide a visual scrim through which distant buildings hide then emerge as one moves through the small garden. Tim Gruner, curator at the Anderson Japanese Gardens, long pruned the pines to maintain their dual function.

The Journey Begins: The DeVos Japanese Garden at the Frederik Meijer Gardens & Sculpture Park

In the Edo period (1602–1868), Japanese warlords built large, complex pond-style stroll gardens as symbols of status and places of retreat. This phenomenon extended around the world a century ago with Japanese gardens for industrialists J. D. Rockefeller Jr (1874–1960) and Henry Huntington (1850–1927), and continues today for billionaires like California's Larry Ellison and Victor Pinchuk in Kiev. Public institutions have also been creating massive gardens that burnish their reputations and contribute to their missions of education.

In 2009, after visiting Japan, Fred Meijer (1919–2011) suggested that a Japanese garden be added to the Meijer Gardens & Sculpture Park founded in 1995 in Grand Rapids, Michigan. CEO David Hooker raised the funds and selected Hōichi Kurisu to create a series of gardens on 8 acres of marsh and hill. Extending the institution's mission to join sculpture and horticulture in the planned Japanese garden, chief curator Joseph Becherer shifted

Above Zhang Huan's monumental steel and copper *Long Island Buddha* suggests the disembodiment and displacement of Asian culture as well as its power to endure in new contexts. It signals the revolutionary nature of the Meijer's Japanese garden.

Left A large water basin, with its flanking arrangement of symbolic stones and semi-formal path, demonstrates one of the sculptural elements found in some Japanese gardens.

Right The conceptual art installation-like quality of Japanese dry gardens is seen in the Zen-style garden where "water" flows in furrows raked around stone "islands."

from an initial idea to show only Japanese sculpture to work by notable international sculptors to honor the worldwide impact of Japanese art. Gradually warming to the evolving challenge, Kurisu contributed to the selection and placement of work by Anish Kapoor, Zhang Huan, Masayuki Koorida, Giuseppe Penone, George Rickey and Jenny Holzer. Holzer worked in creative harmony with Kurisu on the placement of thirteen stones inscribed with texts from Japanese literature expressing diverse Japanese ideas on the value of nature and gardens.[6]

Holzer's resonant poetic themes, sensitivity to the immediate environment and decision to create a subtle art that would "reward the observant" underscore the best qualities of a garden that strives to inspire and restore visitors by connecting them to the realms of garden design and art, but runs the risk of creating an overwhelming spectacle in its ambitious scale and divergent features. As at the Morikami, a path leads around a large pond taking visitors through discreet garden spaces from the entry to a moss garden, bonsai court, Zen-style dry garden, island pavilion, *machiai* waiting shelter and teahouse, viewing hill, moon-viewing deck and zig-zag bridge, all on the garden's west side. The long walk around the pond provides views of most of the sculpture and glimpses across the pond to the architectural landmarks on the far side. The extended path also is a metaphor for life and gardens.

The Meijer leadership uses the motto "the journey begins" to embrace the reality that the garden, in

Left Lotus bloom in the summer, signaling the seasonality planned into the large garden and the Buddhist themes of purity and transience that form a counterpoint to ego-driven human striving for permanence.

Right Masayuki Koorida's polished granite work *Existence* translates the lithophilia of East Asian gardens into modern sculpture, resonating conceptually with the stones in the dry garden. Weeping crabapple trees integrate the five monoliths into the hillside.

Above Dry streams run down hillsides to feed the vast lake at the center of the garden and provide subtle counterpoint to the horizontal paths.

Below The shore is defined
with black pine, Japanese
maple and crab apple, while
the distant hill features sugar
maple, weeping cherry and
spruce. Beneath the zig-zag
bridge, white lotus float on
the water's reflective surface.

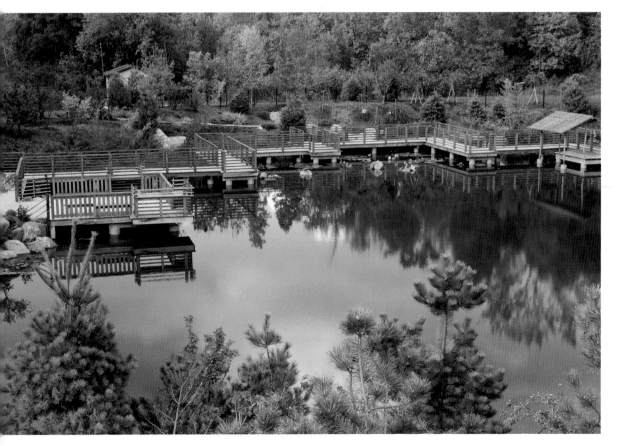

contrast to the sculpture in it, is not a product but a
process. The garden's success is contingent on the
fostering of the plants along with design adjustments
natural to a large garden built in a short time. Equally
important is imagining the garden less as another
attraction on a long day's tour and more as a resource
for local visitors to imbibe, repeatedly, in small sips.
One should experience the garden when the mood
strikes for the encouragement of seeing a plant come
into bloom or endure winter's grip, the contemplative
astringency of the dry garden, the expansive view from
the hilltop, the biophilic connection with koi glimpsed
from the zig-zag bridge or insight gleaned from study-
ing one of the sculptures in relation to its shifting
surroundings.

Holzer's invitation to mindfulness suggests viewing
less in the harried style of the modern tourist and more
in the composed manner imagined of the Japanese
warlord who entered his garden for solitary reflection
or social connection. There, the conjunction of carefully
arranged plants, elegantly placed structures and
evocative art works gave rise to poetic thoughts that
sparked journeys into the imagination. Such voyages
were powerfully enhanced by the crepuscular afterglow
of twilight and the diffused radiance of a rising moon.
These transitional times would amplify Kurisu's fluid
worlds, magnifying the garden's *kisei* with the same
creative spirit that inspired the bold fusion of contem-
porary sculpture and the evolving art of Japanese-style
gardens.

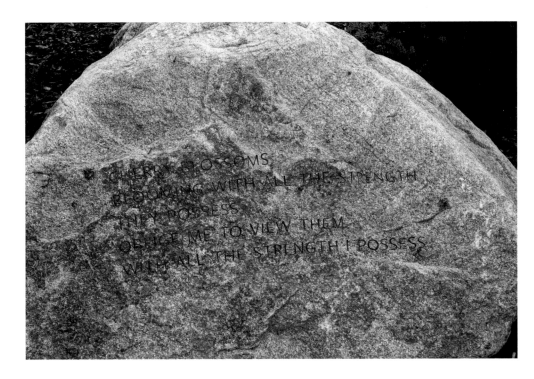

Left On one stone, Jenny Holzer inscribed a verse by modern poet Kanoko Okamoto: "Cherry blossoms blooming with all the strength they possess oblige me to view them with all the strength I possess." (Translated by Makoto Ueda)

Below left Walled courtyards provide intimacy within the 8-acre garden.
Below The powerful north waterfall is one of two that feed the large lake and inject vitality into the landscape.

Joy and Light:
The Spiritual Gardens of Takeo Uesugi

Takeo Uesugi's career as a garden builder is inextricably linked with his life as a head minister for the Tenrikyo church. The Shinto-based new religion holds that joyful living, cultivated though grateful daily practice of charity and mindfulness, sweeps the dust of negativity from the world. Central is the belief that by constructing and tending things with others, adherents walk their own paths of devotion.[1] Uesugi's spiritual belief surely motivated his work and it serves as a metaphor for his style.

Uesugi's gardens are often unassuming, their quiet humility seemingly the personality of the designer. More subtly, the gardens evince joy in their light, open structure bisected by streams and paths that connect humans with nature and with each other. In their physical construction, the gardens tie Uesugi to his teachers in Japan, colleagues in America and eventually his own family. Even as they express an abiding commitment to the humble optimism of Tenrikyo, Uesugi's gardens also demonstrate his desire to bridge Japan and America, the two cultures that he lived between and sought to span in his work.

Takeo Uesugi's landscapes display a sensibility nurtured by and sympathetic to Southern California, his adopted home. In 1971, the year after Uesugi began teaching Landscape Architecture at California State Polytechnic University, Pomona, British architectural historian Reyner Banham (1922–88) published *Los Angeles: The Architecture of Four Ecologies*. In the influential book, Banham defined Southern California by geophysically inspired cultures: beach, flatland, mountain and, most distinctively, road. For Banham, Los Angeles' essence was its multicentered equality and informality; its glory was the liberating flow of the still new freeways.[2]

With a little imagination, these four ecologies appear in Uesugi's gardens made in Southern California: ponds and streams are defined by their shore; broad swaths of plants or lawn constitute a ground plane; rocks and hillocks (with stone from the local San Gabriel Range) create bounding hills; and long sinuous paths move people through this space. While his less effective gardens seem as chaotic as the city's sprawl, the best ones are liberating in their accent on movement rather than destination.

The Accidental Garden Builder

Takeo Uesugi was born early in 1940 in Shitennōji, the working-class heart of Osaka, into thirteen generations of garden builders. (He died in January 2016 as this book was being written.) His father had given up the family business at twenty-nine to become a Tenrikyo minister. Takeo, the fifth and final child, wanted to be a chemist but at Osaka Prefectural University was encouraged to pursue landscape architecture by Prof. Tadashi Kubo. After taking a BS degree in 1962, Uesugi entered Kyoto University's graduate lab in landscape architecture, where he studied with Aya'akira Okazaki (1908–95) and Makoto Nakamura. He was also deeply influenced by the modernist landscape architects Garret Eckbo and Lawrence Halprin (1916–2009), to whom he was introduced by Kubo when they visited Japan.[3]

In 1965, Uesugi enrolled in the Landscape Architecture program at the University of California, Berkeley, working in Halprin's office, then for Royston, Hanamoto, Beck & Abbey. After taking his MA in 1967, he interned with Paul Friedberg in New York. At year's end, Uesugi returned to Japan to design, with Robert Murase (1938–2005), the landscape for the Japan Pavilion at Expo '70. Uesugi entered the doctoral program at Kyoto University, teaching and assisting Nakamura during an era of student unrest. In 1970, he finished his courses and in 1981 began teaching at California State Polytechnic University, Pomona, completing his dissertation on Anglo-American landscape design.

Uesugi set up Takeo Uesugi & Associates (TUA) in 1971 to create contemporary landscapes informed by

Takeo Uesugi combined garden making, teaching and ministerial work to sweep the dust of negativity from the world. Photo by Lisa Blackburn.

his mentors. Halprin's flexible idea of flow spaces that move people through complex settings with "rhythmic structure" would remain one of Uesugi's signal concepts, as seen in his essay on page 45. However, after Uesugi acquiesced to a request to fuse Japanese garden forms with the pool and patio at the Swedlow residence, he began to receive commissions for Japanese gardens.[4] These requests initially troubled Uesugi because they confounded Eckbo's advice to avoid Japanese styles and complicated his own efforts to discover an identity as a Japanese in America. In creating the James Irvine Garden at the Japanese American Cultural and Community Center in 1978, Uesugi accepted his hybrid identity as a Japanese American. Inspired by Kubo's suggestion to adapt the design of the Murin'an garden, Uesugi activated the triangular space with a waterfall, two streams and a pond that symbolize the collective Japanese American journey from immigration to assimilation.

By 1984, when he created an impressive garden at developer Jack Naimann's San Diego Tech Center, Uesugi had adapted Japanese design principles first elucidated in the *Sakuteiki* as a basis for sustainable landscapes that respond to the natural and cultural history of the site. In 5.5 acres between glassy office towers, Uesugi created a complex yet intimate environment utilizing undulating paths across hills and through bamboo groves to lead workers from the abstract perimeters of the garden to various facilities, including a restaurant by a traditional waterfall-and-pond garden.[5]

Uesugi found inspiration in the naturalness, openness and mountain orientation of the famous garden at Tenryūji, Kyoto.

Uesugi's penchant for gardens open to the sky and intersected by sinuous forms is evident in the small entry garden to Costa Mesa City Hall (1975) and in the large Aratani Japanese Garden (1995) at California State Polytechnic University in Pomona. In high traffic areas, the former uses paths though clipped hedges to ease people from the parking lot into the building. In the latter, streams and paths create a complex space at the heart of the campus where people—in Halprin's terms—"activate the environment." These ideas also inform Uesugi's hillside garden at the Huntington Library and Botanic Gardens. Uesugi's sensitive design links the old Japanese House and a new hilltop teahouse by several paths that traverse and ascend a hill that is descended by a stream and a waterfall. The transitional space comes alive with flows of water and people.

Uesugi's attention to human interaction extends from responding to the needs of the client to respect for earlier garden makers. This collaboration across time defined his renovation of the Storrier Stearns Japanese Garden in Pasadena, built by Kinzuchi Fujii between 1935 and 1940, where TUA made the waterfall and pond garden ecologically sustainable by adding a large cistern to catch channeled rainwater. True to Tenrikyo faith, Uesugi worked closely with colleagues, often hiring local garden makers Kinya Hira and Glenn Koyama to install gardens, and sometimes bringing colleagues from Kyoto to set stones. In his last years, Uesugi labored side by side with his son Keiji, who continues to run TUA after his father's death.

Model Gardens from My Youth

The gardens at Tenryūji and Tairyū-sansō in Kyoto greatly influenced my professional practice of Japanese garden design. They are some of the best representations of pond-style stroll gardens in Japan. Similarities between these two gardens include strong patrons, exquisite creativity, site location, beautiful surroundings and borrowed scenery. From these gardens we can learn many traditional garden techniques. But for me, their strongest elements are the flow of pond, stream and path beneath the undulating silhouette of nearby mountains.

Tenryūji, founded as a retreat by Ashikaga Takauji in 1339, with gardens by Musō Kokushi, inspired generations of garden builders with its elegant beauty. Flanked by Arashiyama Mountain and near the Ōi River, the garden's pond seems utterly natural. The garden also connects with the borrowed landscape through the maples that echo those on the nearby hills. Musō Kokushi's rock arrangement, displayed in the famous waterfall and pond edge, has deeply impacted my style of flow and elegance.

Tairyū-sansō is a villa built in 1896 by the prominent businessman Ichida Yaichirō, with a garden designed by Ogawa Jihei (aka Ueji). Ueji's exceptional talent is seen in the cleverness of the layout, its integration with the sukiya (tea-style structure) architecture of the villa and lovely details. Together with the garden manual Sakuteiki, this garden has given me the chance to study living traditions.

I am grateful to have had Tenryūji and Tairyū-sansō as such wonderful models from my youth. I treasure them as lifelong inspirations.

Takeo Uesugi

Confluence in Three Dimensions: The Grand Hyatt Atlanta

Although prevalent in Southern California, Takeo Uesugi's gardens are found right across the country, including at the Bannockburn office complex near Chicago, the Mobile Japanese Garden in Alabama, and in several residences. His best-known project is the uncharacteristically dramatic garden for the Grand Hyatt Atlanta, originally the New Otani, a Japanese hotelier that sought to brand its properties with gardens.

At the 25-story neo-Georgian hotel built in 1990 in the Buckhead district, Uesugi created two gardens. Filling a huge court and dominating the view from the entry floor lobby, two ground-level restaurants and all of the back-facing rooms, is a three-story waterfall garden. A three-level outcrop of textured, poured and painted cast stone is divided into rough thirds by two cataracts

Opposite above In the rooftop tea garden, a stone inscribed *washin raikō* (a peaceful mind brings happiness) appears through bamboo.
Left With its low bridge, lanterns and simple gate, the intimate tea-style garden on the third floor provides a place of escape in a large hotel.
Right The magnificent three-story waterfall garden is accessed from the ground floor terrace, where a legged lantern in the pond creates a visual transition.

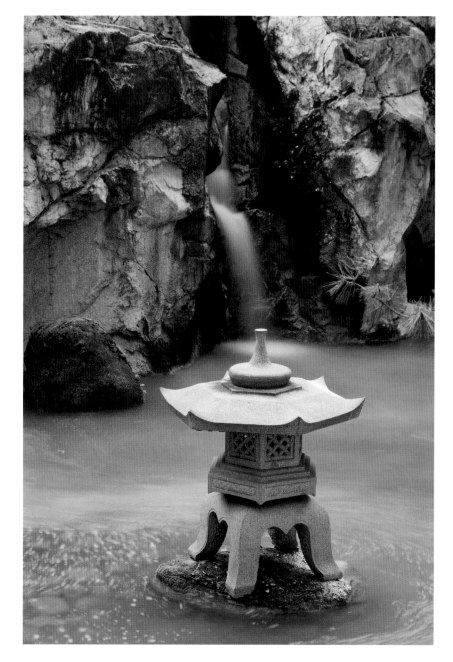

Above Scattered cherry blossoms fill a stone water basin resembling a flower. In contrast to the drama of the adjacent waterfall, here water moves a drop at a time, creating calm and inviting reflection.

Right Uesugi breaks up the mass of the multi-story waterfall by stepping it back with planted terraces and trisecting it with parallel cataracts. In this fluid world, the sky flows to the earth as trees reach for the heavens.

which pull the eye 30 feet from a viewing pavilion atop the cliff to a pond at its base. The massive rock form is softened by falling water, lithesome Japanese maples planted along its shelves, sculptural pines and a small stone lantern in the pond as counterpoint.

The top of the cliff, accessed from the third floor, is comprised of an extended tea-type garden whose quiet horizontal flow balances the vertical orientation of the waterfall garden and bookends the pond and patio at its base. Entered from either side along *nobedan* paths made of cut and carefully laid pavers that lead to simple gates, the garden path turns informal, twisting through a grove of cherry trees and past water basins to a viewing pavilion. The rustic structure allows views of the tea garden and the waterfall dropping below it. The light elegance of the tea garden contrasts with the heavy faux European hotel architecture and the drama of the waterfall. Although requiring substantial fostering, the gardens are reportedly popular with guests and wedding parties who can view the waterfall or be enveloped by its sound from the terrace.

Light and Space by the Pacific: The Uyesugi Residence in Malibu

Left The tea garden path traverses the property's narrow west side to emerge at the swimming pool/pond, where a lantern signals the transition to the tea ceremony room.
Opposite Seen from the house, the sculpted pine and waterfall form a visual boundary and point to the silhouettes of the Palos Verdes Peninsula and Catalina Island.

Takeo Uesugi & Associates (TUA) created many residential gardens, most with ponds, pools or both, but none as dramatically situated or fully integrating house and garden as in the Uyesugi (no relation) residence perched on a bluff above the Pacific Ocean. The intimately scaled home contains three distinct gardens that reflect the owners' family connections with Japanese gardens through parental hobbies and the ongoing practice of tea. The joint creation, with Uesugi utilizing both local and Japanese subcontractors, speaks to the designer's spiritual values as strongly as does the immense delight of viewing a garden that seems to merge with sky and ocean.

Most visitors encounter a garden when they first enter the house because the foyer and entry hall are lined with stones and small plants in the manner of the courtyard and entry hall gardens common to Kyoto. Oblique views of the backyard garden and the Pacific Ocean pull visitors into the living and dining rooms, where the pool-and-waterfall seems to float against

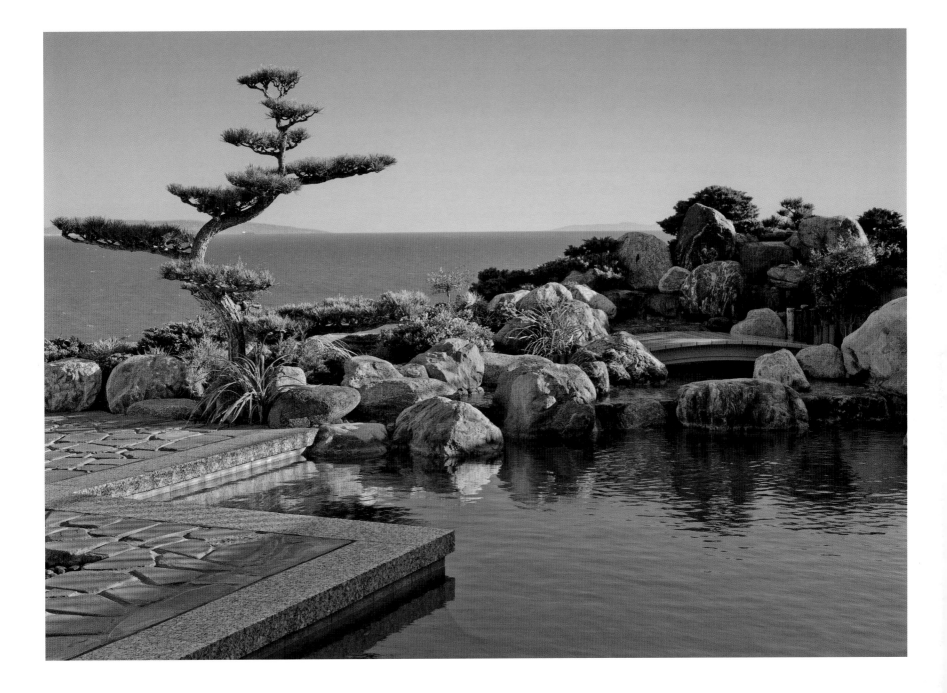

In a purification ritual key to the tea garden, guests and students kneel at the low water basin to scoop water over their hands. Plants with fine leaves and subdued colors harmonize with the patterns and tones of the stones.

swaths of green and blue. Students coming for an Urasenke tea lesson skirt the house's right side, crossing a small bridge, passing through a gate and traversing a narrow tea garden (*roji*) passage between the house and wall. Walking carefully over stepping stones past a *chōzubachi* water basin and lantern, the pool-and-waterfall garden comes into sight before guests ascend the verandah to the tearoom.

Locating a waterfall garden high on a bluff over the ocean is almost as audacious as Kurisu's balcony garden in Chicago. Like it, Uesugi's design succeeds because the low, sleek silhouette bounds space even as it allows

borrowed views of the Pacific, Catalina Island and the Palos Verdes Peninsula. Beautifully scaled and placed stones and an aggregate edge integrate the pool and waterfall into the sparsely planted garden. For all the grandeur of the scene, set off by the small lantern, the garden harmonizes with the flanking homes. To the east, plants are kept low to lead the eye over red bougainvillea and tile rooftops along the edge of the coastal hills. Los Angeles' four ecologies exist in the garden and beyond it, these micro- and macroscopic realms connecting in an exhilarating fusion of form and void.

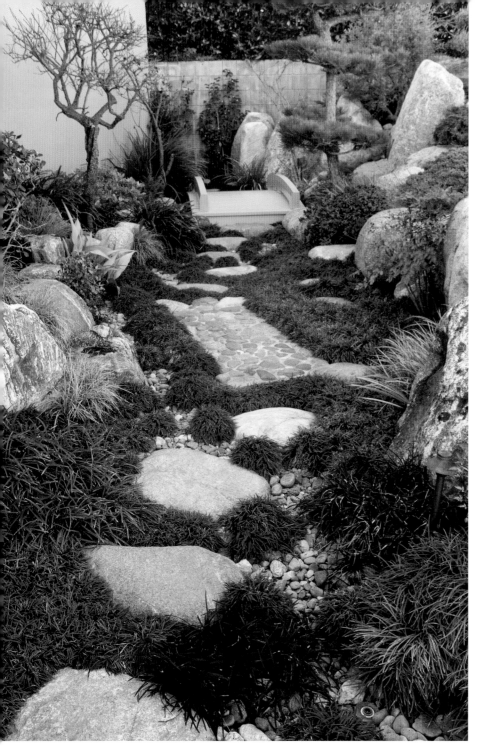

Right The inner tea garden includes an inset bench (top left), where guests wait before being summoned through the simple gate. The spectacular vista of the pool and ocean emerge after one passes through the gate.

Left Tea guests to the home walk through the outer tea garden, cross a bridge, then turn left around the house to access the inner tea garden. Among the monochromatic plant palette, a blooming azalea catches the eye.

A Garden That Comingles with the Sea

For us, the garden is a beautiful organic representation of Japanese culture and way of living. We purchased this house knowing we would add a Japanese room for traditional tea ceremony, and creating a garden seemed organic to the design. In tea, the garden is a reminder of human connection with nature. Also, George grew up around Japanese gardens since his father loved his hill-style garden in Japan and practiced pine pruning as well as bonsai.

The gardens surrounding the house provide serenity and harmony. With the Pacific in the background, the garden emphasizes the dynamic beauty of the ocean. The sound of the waterfall comingles with the sound of the sea for a soothing effect. Visitors often tell us that they enjoy the beauty of our garden that blends into the sea. The garden itself is like a living being as the plants reflect seasonal changes. With the care we provide, we feel rewarded by the garden's elegant beauty.

Working with Takeo Uesugi was uniquely rewarding. He understood our vision and introduced us to experts who executed the work. We appreciated his expertise, personal interest and broad network. Dr Uesugi arranged for Mr Tamane, chief gardener at the Golden Pavilion in Kyoto, to install the large stones in the indoor and tea gardens. We were fascinated to watch this quiet gentleman in his seventies manipulate each stone to determine its best angle, show its "face" and harmonize with other elements. A gentle soul loved by many, Dr Uesugi cherished his family and his work as a scholar and garden creator. We feel honored and fortunate to have known him and to have been his friend.

George and Yuko Uyesugi

Left The silhouette of the *yukimi* snow-viewing lantern pulls the Palos Verdes Peninsula into the Uyesugi garden, while the floating light projects the backyard landscape into its expansive environment.

Above Inside the house, the entry hall is flanked by potted plants and stones, with the pool garden visible through the rear window.
Opposite Uesugi's desire to work with partners from his student days in Kyoto resulted in many stones being set by Tokushirō Tamane.

Following the Path: The San Diego Friendship Garden

Opposite Dry and liquid streams meet at the earthen bridge.
Left The formal bridge sits above the dry stream, up canyon.
Below The Inamori Pavilion hosts events and exhibits. Photo by Jeff Durkin, courtesy of Roesling Nakamura Terada (RNT) Architects.

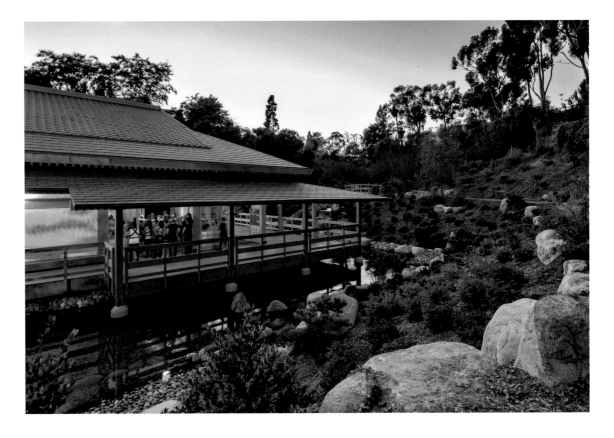

Together with the San Diego firm Fong and LaRocca, Uesugi first submitted a master plan for the large San Diego Friendship Garden in Balboa Park in 1979. Board gyrations led to alternate designs by Kōichi Kawana, then a first phase design by Ken Nakajima of Tokyo in 1990.[6] Uesugi was brought back for the project's second phase, an extension along the narrow rim of Gold Gulch Canyon with a new entry area, waterfall-fed pond, pergola and patio, and a bonsai garden around spacious offices completed in 1999. The distinguishing feature is the elegant path that curves past the original building and dry garden on its way to the Dail Gate, portal to the final project. The 9-acre third phase extends the garden into the canyon. Built between 2010 and 2014, it centers on the large events pavilion and attendant building designed by Kotaro Nakamura of RNT Architects. In this final project, made while fighting cancer, Uesugi worked with his son Keiji and many old friends. He placed large stones with Tokushirō Tamane and in the summer of 2014 with Makoto Nakamura, the two old men delighting in one last garden project.[7]

The new garden features a long, gentle ADA-compliant path leading down the canyon to the pavilion. As it swings along a hillside covered with azaleas and

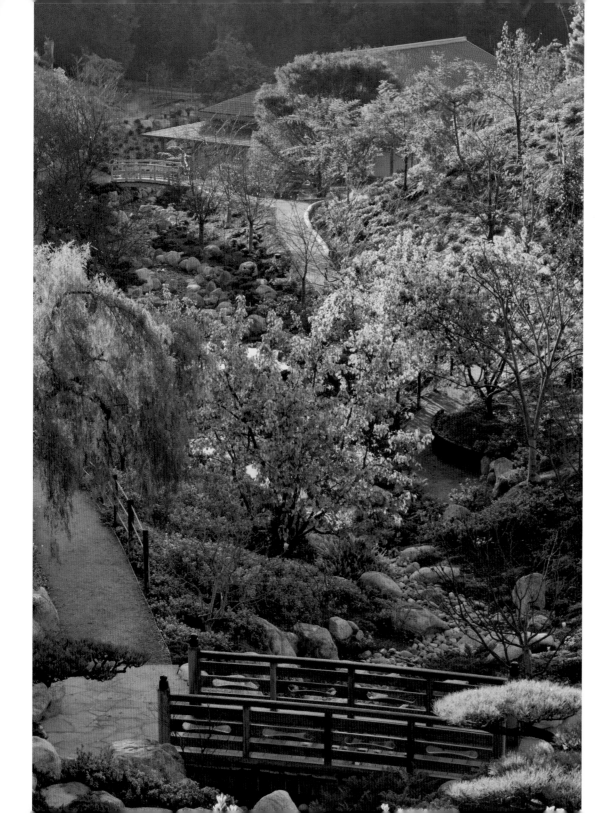

Above A stepping stone path allows visitors to ford the stream as it traces the canyon bottom. In the most lushly planted section of the 9-acre landscape, azalea and camellia varieties bloom from winter to late spring.
Left Glimpsed from a terrace above and outside the garden, paths and bridges pull viewers' eyes to the events pavilion in the distance.

About 200 specially grafted cherry trees provide a graceful canopy above the winding paths in a garden that evokes the arroyo, or dry rivers of Southern California.

other shrubs, and planted with specially grafted cherries, it traverses a dry stream, then an actual stream. The sinuous waterway and path descend in tandem to the pavilion sitting dramatically below a broad waterfall. From the pavilion's broad verandah, the stream becomes a mesmerizing focus, shutting out the bowl of hills. As with Kurisu's Japanese Garden at the Meijer, the Friendship Garden's success will depend on skillful fostering of the plants. And for visitors to fully enjoy Uesugi's subtle creation of fluid space, they need to be mindful of the immediate environment in a space where landing planes move through the background. The garden fantasy best takes place in the evening when twilight quiets the sky, softens the land, "floats" the pavilion and makes magic with the water that flows joyfully moving, forever connecting.

The Nature of Gardens:
David Slawson's Sense of Place

As both garden maker and historian, David Slawson has sought to shift the understanding of Japanese gardens from an exotic style based on museum piece objects to a set of adaptable ideas used to create landscapes that evoke the places where they are built. The nature of Slawson's gardens is the landscape of North America. In adapting Japanese garden principles to create new and regionally relevant gardens instead of copying old gardens, Slawson positions himself in a lineage from Josiah Conder and Samuel Newsom.[1]

Unlike walled gardens that create places apart, Slawson's gardens gently fuse with surrounding landscapes. Their pleasure and purpose is a greater awareness of regional landscape gained from having seen it beautifully manifest in microcosm. The subtlety of Slawson's gardens means that for people not attuned to their theoretical and aesthetic frequency, they can be missed altogether. More frequently and more happily, they are mistaken for natural landscapes. For those aware of their concepts, creative enough to interpret the forms and sensitive to the skills required to express them, these gardens provide special rewards.

Slawson positions his gardens within the nature-based arts of East Asia that are founded on perceptual resonances between created and natural worlds. The premise is that man-made evocations of nature can provoke the same or greater response as nature itself. Slawson often cites Chinese Song dynasty landscape painting as an inspiration and, like these pictures, many of his gardens suggest optimal viewing from one spot. From a framed or otherwise marked place, asymmetrically balanced rock and plant clusters in major and minor groupings move the eye through space. Both his dynamic compositions and forced perspectives to suggest depth are based on carefully considered proportions, often using the golden mean. Like a painter grinding his ink then applying the right mix of texture strokes, Slawson selects rocks and plants for scale, tone, texture, age and appropriateness to region, then places them with exacting care.

The "Accord Triangle" is Slawson's name for his design philosophy predicated on evoking the beauty of the natural world in response to the qualities of the site (including organic and architectural contexts), the client's needs and desires and the region's character in terms of topography, materials and weather. At its best, this place and person-derived approach, together with Slawson's experience in Japan with Kinsaku Nakane, produces gardens that capture a place in time. Or, in Slawson's term, they are timeless.

Finding Self, Evoking Landscape

Born in Cleveland, Ohio in 1941, David Slawson was raised in the suburb of Parma. Although the fastest growing city in America during his childhood, forests could still be found nearby. Slawson's early memories of magical experience in nature would remain a signal inspiration in his life, manifest in his hobbies of backpacking and sketching as well as in his career writing about gardens and building them.

After graduating from high school, Slawson sought to find himself during a four-year hitch in the Marines. In fact, he found himself sent to Japan. From his base in Iwakuni, Slawson explored the culture (studying the *samisen* lute) and the country. He traveled from the mountains of Hakone to the gardens of Kyoto, where he sat for hours. Back in Ohio, Slawson studied philosophy at Kent State University, graduating in 1969. With a grant from the East-West Center, he took an MA in Asian Studies at the University of Hawai'i, fashioning his own study of Japanese art and gardens at a campus noted for Kenzō Ogata's garden. A six-month in-country internship, arranged through Zen Buddhist philosopher Shin'ichi Hisamatsu (1889–1980) by visiting scholar Masao Abe (1915–2006), led Slawson to Kinsaku Nakane. Working with the master and his disciples in Kyoto in 1971–72, Slawson experienced gardens and garden making first hand, absorbing the lessons with both mind and body.[2]

Returning to Ohio where he had earlier made a stone-and-moss garden in his parent's yard, Slawson sought to create gardens for the public. In a cascading dry waterfall on a steep hill at the Cleveland Botanic Garden, Slawson fused the famous waterfall stone arrangement at Tenryūji with Nakane's fluid style. A year later, in his Garden of Quiet Listening at Carleton College, meant to be seen from the viewing pavilion, Slawson merged the compositional balance of form and void from Southern Song painting with an evocation of local place. This lyrical distillation of the quiet rivers and low bluffs of central Minnesota would win Nakane's praise and establish Slawson's reputation.[3]

Slawson's path led next to the University of Indiana's PhD program in East Asian Languages and Cultures under Kenneth Yasuda (1914–2002), a scholar of Japanese poetry and garden designer whom Slawson had met in Hawai'i.[4] On Fulbright-sponsored research in Japan in 1980–81, Slawson worked with garden scholars, including Makoto Nakamura of Kyoto University. In 1985, Slawson finished the dissertation that would become *Secret Teachings in the Art of Japanese Gardens*. In part a translation and discussion of *Senzui narabi ni yagyō no zu* (Illustrations for Designing Mountain, Water and Hillside Field Landscapes), the book ranges widely over Japanese garden history. Full of design strategies that Slawson would later employ, the beguilingly titled book helped position Slawson in the Japanese garden field.

Above David Slawson creates biocentric gardens that, like Song dynasty landscape paintings, capture the power of natural places. Photo by Sylvia M. Banks.
Opposite At Kyoto's iconic Ryōanji, Slawson first realized the power of Japanese gardens.
Previous spread The waiting arbor is an ideal viewing spot for the Garden of Quiet Listening at Carleton College, Northfield, MN.

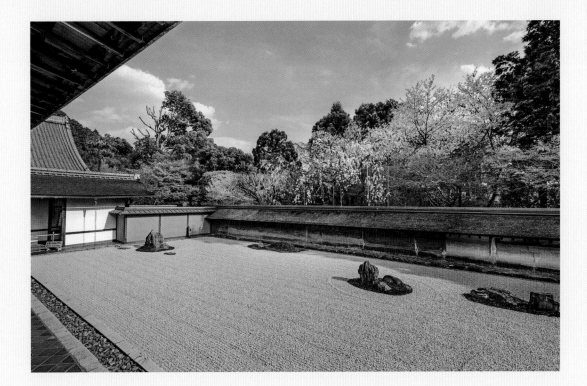

What Three Kyoto Gardens Taught Me

In 1963–64, while serving as a Marine in Iwakuni, I flew with a friend to Tokyo then hitchhiked back, stopping to climb Mt Fuji and visit Kyoto. Two college students offered to guide us to several temple gardens, including Ryōanji. Two hours gazing at the dry garden allowed the sensory qualities of the fifteen rocks arranged in five groups to permeate my senses, touching a place deep within. This is when I first became aware of the subtle power that comes from rocks disposed in space.

Many gardens in Japan skillfully depict natural scenery but few match the power of the dry landscape at Daisen'in to evoke the ever-changing qualities of a stream on its journey from mountains to sea. Emerging from twin peaks as a whitewater falls, it flows under a natural stone bridge past descending foothills as it widens into a river with distant cliffs visible through the mist. A boat-shaped rock glides by gentle hills on its way to port. Such scenes had been captured in ink paintings, but seeing it done in a garden made me want to learn this fascinating art.

Tenryūji garden taught me lessons in naturalistic composition on a larger scale. A dry cascade tumbles down a hillside between craggy boulders into an inlet crossed by a triple-stone bridge. Like a Song ink landscape, a horizontal line provides a counterpoint to the cascade and a seven-stone islet jutting from the pond. The famous peak Arashiyama is brought into the garden so artfully it appears to be part of it. Once again I was moved by garden art elevated to the level of landscape painting.

David Slawson

Sage Mountain Sky: The Garden at the Aspen Institute

Through the Garden of Quiet Listening, Slawson met Carleton College donors John and Betty Musser for whom he designed a garden at their Aspen home. After John died, in 1994 Betty gifted a garden in his honor to the Aspen Institute, a Washington DC-based policy and educational organization with a 40-acre facility in Aspen. In contrast to Herbert Bayer's modernist earthworks, which diverge dramatically from the bucolic Aspen site, Slawson's Japanese contemplation garden seeks to harmonize with its surroundings.

Located at the edge of a field separating a parking lot of the Aspen Institute from the Music Tent, the garden is composed of a stone-lined stream flowing past a bed of gravel bordered by stones, shrubs and trees. Because it is so naturalistic, a small plaque advises visitors, "The gravel represents a mountain lake. Please view it as you would a painting from the paths and benches." Slawson was inspired by and sought to distill the spirit of Roaring Fork watershed that flows 50 miles from Aspen to Glenwood Springs.

Left The humble garden, off a path near a grove of aspen, responds to the topography of the site and the larger region. It focuses attention on the relation between water running through the earth, powerful rocks, distant mountains and enveloping sky.

Above Long, low stones encourage visitors to stop, sit and view the garden that begins under their feet.

The garden was created with local landscaper Keith Keating, who built the stone water weir that channels water from a nearby ditch into the delicate stream that animates the garden. The horizontal and vertical boulders came from the foot of Red Mountain. In addition to aspen and several kinds of native ground cover, Slawson uses blue spruce and ponderosa pine to screen out nearby buildings while lifting the eye to the distant mountains and, ultimately, the sky. The garden's evocative name comes from a sage plant on the site, the powerful form of Shadow Mountain and the sky. In the Japanese name for the garden, the *kanji* chosen for sage is "sacred" or "wise man," referring perhaps to the sacred landscape or the sagacious John Musser.

Right The stream seems to feed an ecosystem now thinned but initially composed of dwarf Scotch pine, arctic willow, mahonia, cinquefoil, alpine dwarf potentilla, dragon's blood sedum, Irish moss and local wildflowers.

Slawson usually avoids boundary fences in gardens meant to merge with surrounding scenery. Here, the fence provides a foreground focus that parallels the background of Engelmann spruce, ponderosa pine and serviceberry which screen a parking lot.

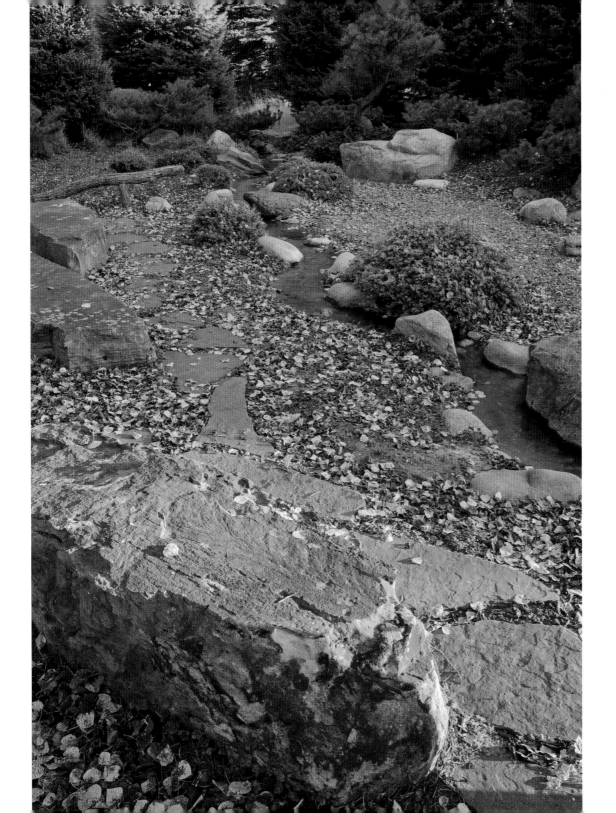

Above A plaque alerts visitors to the garden's presence, its poetic name, and suggests how to view it.

Landscapes for Evolved Living:
Minnesota's North Shore at the Hoeschler Residence

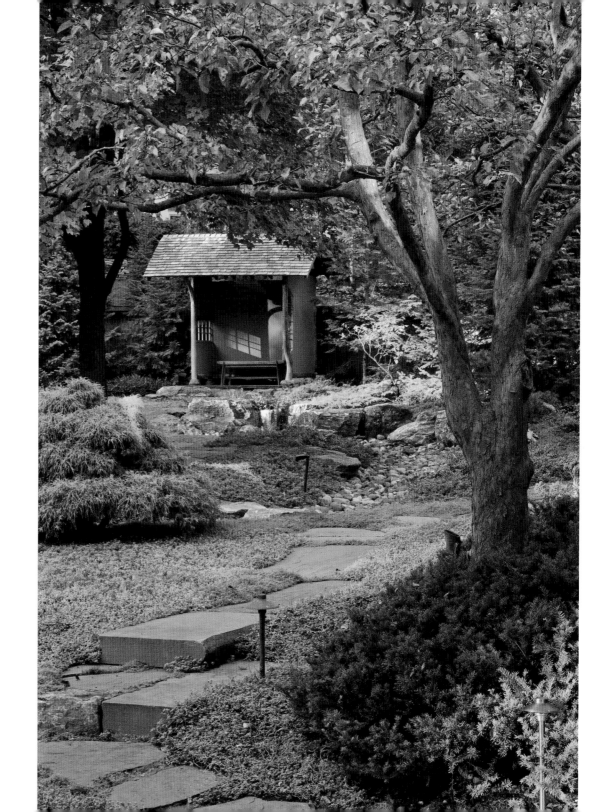

In a form of garden karma, the Aspen Institute garden gave rise to a landscape suite for Jack and Linda Hoeschler in St. Paul. The story of these gardens, built over a period of twenty years, is best told by the owners. A few details fill out the picture of a garden born when Slawson was renovating the Japanese garden at the Minnesota Landscape Arboretum, then evolved in response to sensitive clients and finally matured under Slawson's designated follower John Powell.

The initial lake garden utilizes over seven tons of granite boulders from quarries in Shakopee as well as smaller stones and rounded beach pebbles from the North Shore. Although large, the garden seems grand because the hawthorn and maples on the peninsula and

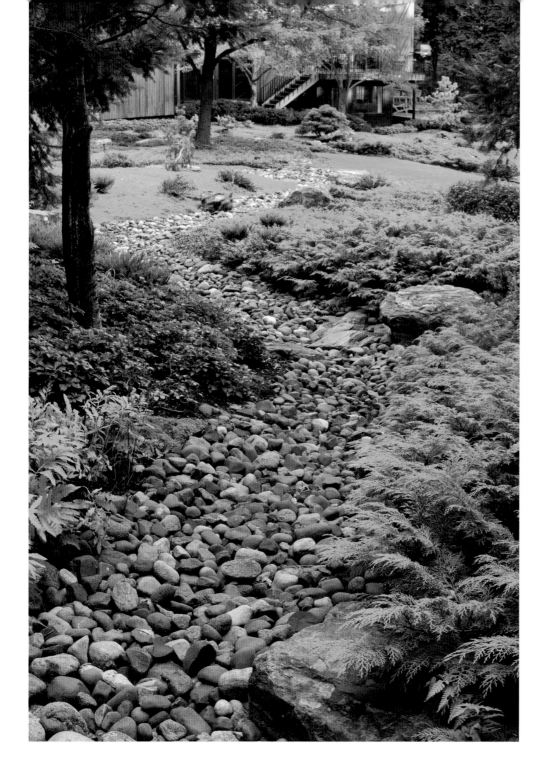

Left From the covered *machiai* waiting arbor, where traditionally visitors wait to be summoned to a tea ceremony, the dry steam curves down past the residence to feed the large conceptual lake.
Above Part of a totally designed property, a shady corner of the lower garden contains a rustic bench.

Opposite above A basalt basin near the *machiai* suggests a glacier-carved lake and symbolizes the garden's orientation to Great Lakes geology.
Opposite right Reached by a stepping stone path and overlooking the dry stream, the *machiai* shelter establishes a visual boundary.

Left Buffalo grass ripples in the lake while hawthorn groves rising among pachysandra defines an island and far peninsula. On the near shore, a contorted Uncle Fogy Jack pine lifts its head from a bank of low-growing dwarf Japanese garden juniper, sedum and thyme.

Above The Lake Superior North Shore theme evolves into a forest stream in the courtyard garden, visible from the entry court and office.

island pull the eye horizontally even as the euonymus-lined far shore evokes distant hills. In contrast to this broad panorama seen from the house and deck, the courtyard garden is intimate, its appeal rooted in the tones and textures of locally quarried stones. The dry steam garden is small in scale, flowing through a gentle meadow and bordered by moss, microbiota, balsam and birch trees, evoking a North Shore forest. The Hoeschler's commitment to a high-quality landscape led to removing trees and resculpting the land above the lake garden to add the dramatic dry stream that completes this powerful evocation of local place.

Living with a David Slawson Garden

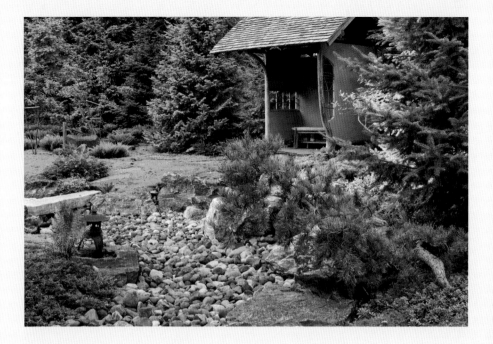

In the late 1980s, after raising our family in a mid-century modern home designed by Ralph Rapson, we incorporated more Japanese artifacts and design elements, such as *shōji* screens, to make it more restful and soften the light. We tried to complement the interior with exterior garden rooms appealing in all seasons but were dissatisfied with our amateur attempts. In 1990, we read *Secret Teachings in the Art of Japanese Gardens* by David Slawson, then fortuitously met him in Colorado in 1994. We particularly liked his philosophy of interpreting local terrain with a Japanese aesthetic and technique but using local materials.

David conceived our southwest garden to evoke the rocky North Shore of Lake Superior. Work began in May 1996 with the resculpting of the land to suggest a rocky beach, lake, peninsula and island. Terminal moraine granite boulders, North Shore stones, trees and shrubs were brought in and placed. The water in the lake is buffalo grass. Uncut, it ripples like water in gusty winds. Later we added the huge iron ore boulder cliff and lantern to anchor a corner of the lake.

Once David installed this garden, the rest of the yard looked weak. In 1997, he designed a dramatic courtyard entrance garden, inspired by North Shore gorges and streams. This installation incorporates stunning boulders that are particularly pleasing since we view them most often from our bordering bedroom. We savor the way some rocks hold the snow and rain. East from the courtyard, a dry stream meanders through a gentle meadow bordered by trees, similar to a North Shore forest. Over the years we have pulled out some of the edges and added small boulders to better evoke a Lake Superior stream. In 1998–99, David designed and together we executed a quiet south garden that invites the eye and foot to travel from one of the lower bedrooms to a hillside overlook. Each year we develop the gorge, experimenting with shade-tolerant, deer-resistant plantings.

In 2004, we asked David to incorporate into the garden a grassy swath above the lake. Now a tumultuous stream rises from a stone chasm, tumbles diagonally toward our house through a fern-dotted forest, enters a peaceful meadow, winds around an island, then twists through a gorge

and falls into the lake. Stone footbridges and paths invite exploration. In 2006, we added a stucco *machiai* shelter near a natural basalt fountain to anchor this stream garden and offer a protected, panoramic view. We love both the energy and peace of David's boldest garden.

We converted our garage to a library and built a new garage in 2008. Besides providing a new viewing angle for the west garden, this addition also created a new entry courtyard. There David perched basalt basins to suggest glacial lakes in a hemlock forest clearing. Two years later, David invited John Powell to help manage our garden on periodic visits. John has transformed it by adding compact gardens, new rocks (in addition to repositioning existing ones) and plantings, and by pruning. He has also tended to critical details such as the burned wood *amaochi* pole at the *machiai* dripline. The garden looks fresher, more defined and graceful with each visit.

Another key to enjoying our garden is the substantial lighting designed by Jim Hewitt. We illuminate not the entire garden but highlight certain rocks, special trees and part of a streambed or path to suggest the underlying shape of the whole. Lighting extends our viewing pleasure and allows us to savor the seasonal gifts our garden offers.

Jack and Linda Hoeschler

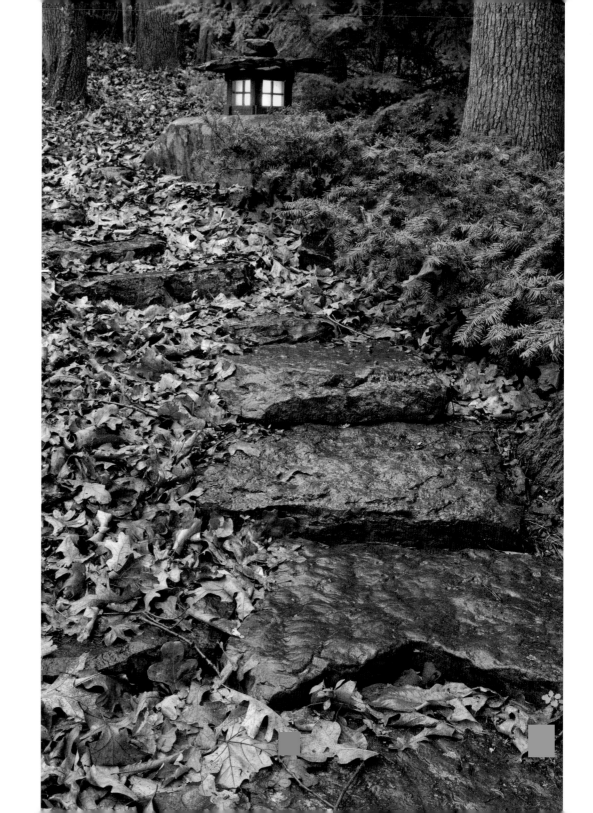

Integrating Life and Landscape:
An Ozark Glen at the Heinzelmann Residence

Dr Peter and Margo Heinzelmann have many passions. Two of the most intense are collecting the Japanese art that fills their home and enjoying the beautiful natural sites of the Ozarks, where they co-founded Fayetteville Natural Heritage to protect areas in their adopted home town. In 1997, they decided to make a Japanese garden on the slope behind their secluded ranch-style house. There was no doubt that they would adapt the gentle beauty of the Ozarks and after reading his book ask David Slawson to create it.[5]

The Heinzelmanns showed Slawson their favorite woodland streams, pointing out how long, narrow pools lead to short, shallow areas then spill into the next pool.

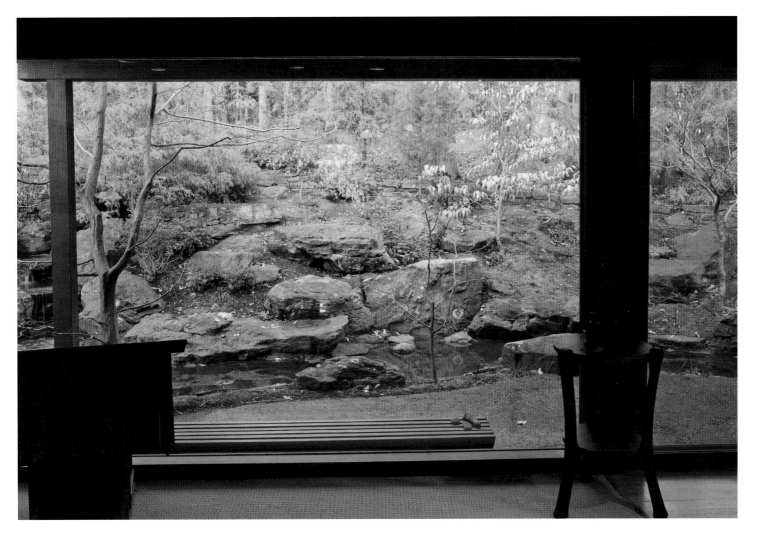

Opposite above The hillside Ozark outcrop is entirely man-made, the stream recirculating water by pump and pipe.
Opposite right To contextualize the Japan-inspired patio garden, the owners asked Slawson to use stepping stones and lanterns to extend the garden into the adjacent hillside covered with red oak, red cedar, eastern hemlock and beech.

Above A picture window was installed in the living room to frame the garden composition of sandstone bluffs animated by a gurgling stream, softened by light-leafed gumpo azalea and Japanese holly and shaded by sinuous flowering dogwood, eastern redbud and Japanese maple. A bench, picking up the stained wood of the window frame, creates a transitional space between house and garden.

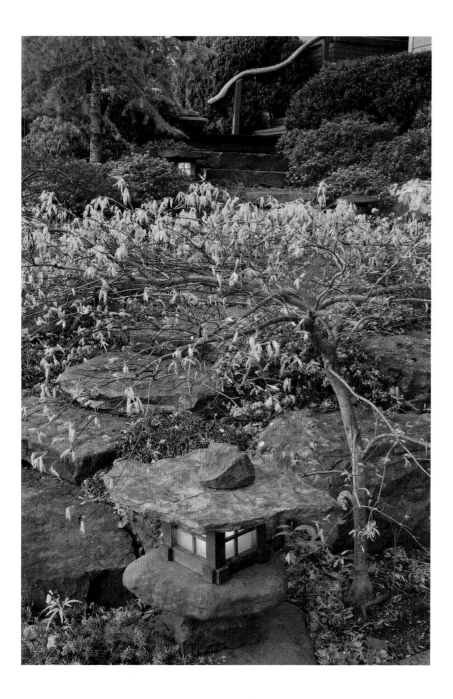

Using about 75 tons of lichen-covered sandstone boulders from a local site, Slawson created a series of small bluffs over which a stream gurgles through small pools and falls. The watercourse starts north of the house, above a guest room, then descends to the south, ending in a pond near a deck outside the kitchen. The center of the garden, where a low stone bridge crosses the stream, flanks the living room. Slawson persuaded his clients to reveal the garden by replacing the fireplace with a huge picture window. Local plants, including American and blue beech, redbud, maples, azaleas, ferns, witch hazel and moss, soften the rock terrace, provide shade and add colors from greens to pinks.

Over the next twelve years, inspired by this garden that projects their Japanese landscape prints and paintings into three dimensions, the Heinzelmanns worked with Slawson to extend the Japanese-inflected environment around the rest of their property. These additions include the azalea, pine and maple-planted hill in front of the house that is accessed by stone steps set with small lanterns. On the house's south side, a humble gate beyond the informal moss-lined stone patio leads to a stepping stone path. It climbs the hill, crosses a rustic bridge over a dry stream, to an *azumaya*, a traditional arbor or summer pavilion found in formal Japanese gardens. The rustic shelter looks through the woods to the garage, disguised as a Japanese house. Slawson's discrete addition of rock outcrops, Japanese maples and lanterns bring out the beauty of the site, making it both a vital landscape and a place of deep repose.

Along the steps leading to the front of the house, the dainty leaves of dwarf satsuki azalea, boxwood and Japanese bush holly expand the perceived scale of the composition and harmonize with varieties of pine and maple. Pachysandra, fern and crested iris cover the ground.

Left A simple gate leads to the hillside path and eventually a rest shelter. *Below left* The rustic elegance of the entire garden is encapsulated in the moss-lined patio between the waterfall and hillside path.

Right To maintain the illusion of a Japanese vignette in the Ozarks, the garage roof is given the hipped-and-gabled design of a Japanese temple or teahouse.

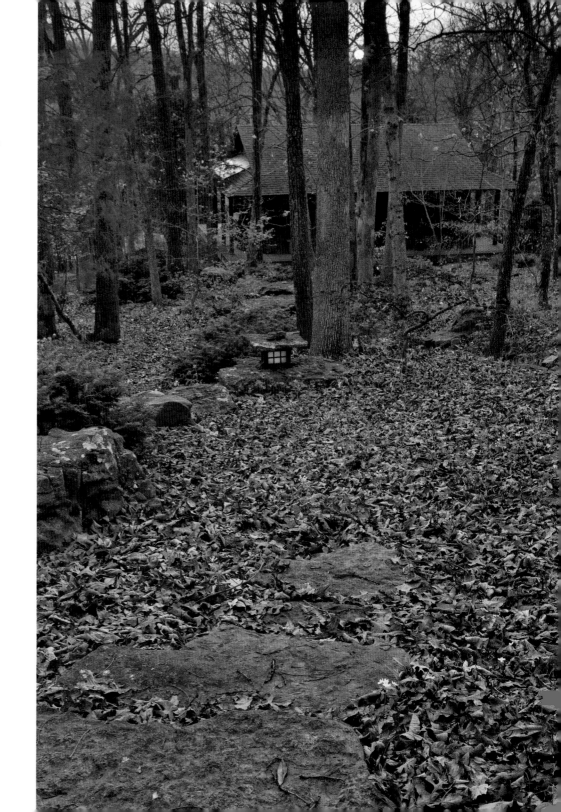

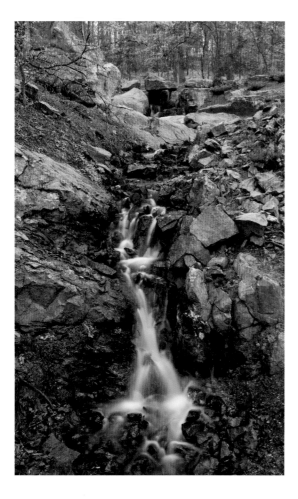

As with his other gardens at Garvan, Slawson worked with a talented local crew to build the watercourse and set each stone in order to transform a rough slope into a dramatic mountainscape.

Mountain High:
The Floating Cloud Bridge at Garvan Woodland Gardens

Slawson's inspirations, from the pictorial landscapes of East Asia and the living landscapes of North America, merge again in his suite of gardens at the Garvan Woodland Gardens. At the botanic display in Hot Springs, Arkansas, Slawson created the Garden of Pine Wind (2000–04),[6] the Welcome Center area and bonsai garden (2006–07) and the Children's Adventure Gardens (2011) before fashioning the garden of the Floating Cloud Bridge between 2010 and 2014.

Perched on the path from the Garden of Pine Wind to the Camellia Trail, this dramatic vignette transforms a steep drainage ravine into a compelling evocation of the Ozarks, filtered through the dreamy landscapes in woodblock prints and ink paintings that often create the sensation of looking down from a mountaintop. Water pumped over hundreds of tons of stone turns the ravine

Left A 12-foot-high, 16-ton stone serves as a focal point and anchors the bridge, which is cantilevered off the side of the hill.
Below Above the bridge, a stepping stone path invites exploration of the forest.

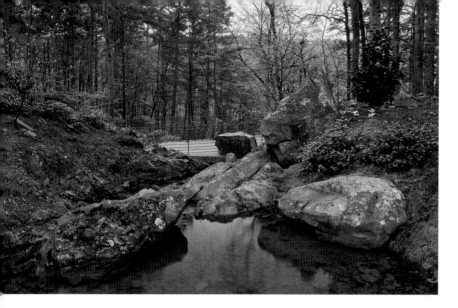

Left The pump-fed stream pools before spilling down the hill and under the bridge.

Opposite The hillside is planted with Yoshino cherry, blue Pacific juniper, five varieties of holly and three kinds of white-flowered azalea that will mature into a mass of cloud-like blossoms in spring.

Below The natural effect is achieved in part by Slawson's planting of large stones into the hill apart from the bridge area.

into a gentle mountain cascade spanned by a bridge seemingly perched on six massive vertical boulders. The largest is 12 feet high and weighs 16 tons. From the main path, stepping stones ascend the hill into the woods. The "floating cloud" name refers to the gossamer forms of cloud-pruned white azaleas, cherries and redbuds. The design balances the mass of the stones with the dynamism of flowing water and the ethereality of blossoming trees.

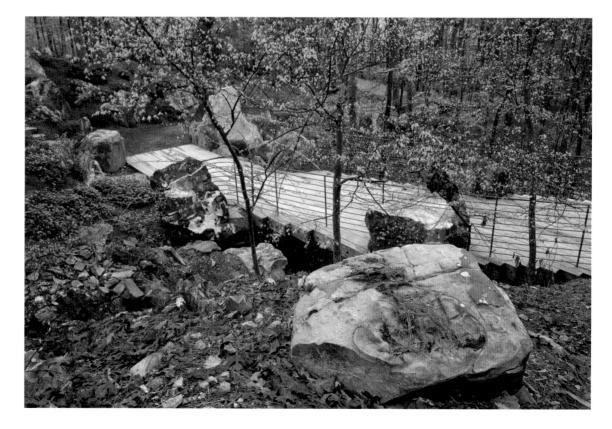

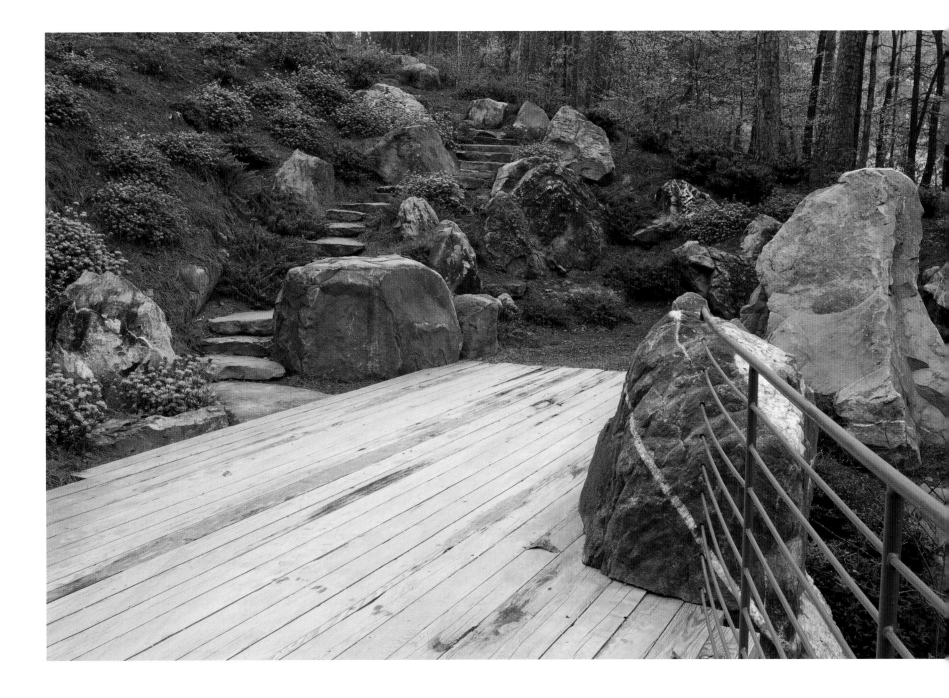

Modernist Space:
Shin Abe's Dynamically Balanced Gardens

Shin Abe's characteristic gardens are modern, even modernist, with crisp lines and forceful contrasts in tone, texture and shape. His ideas, however, are organic, evolving with his acquisition of knowledge gleaned from broad experience filtered through an inquisitive intellect. Abe's sources are diverse, including the avant-garde gardens of Isamu Noguchi (1904–88) and the neo-traditionalist ones of Kinsaku Nakane. The styles of his gardens, ranging from traditional Japanese gardens to his trademark abstraction, are also tailored to the client's wishes. Abe thus seems a model of post-modern hybridity, translating Japanese garden forms into the diverse languages understood by contemporary audiences.

Abe listens hard to the ideas and needs of the client, likening himself to a private dancer. He is also keenly attuned to the physicality of each place. His response to the spirit of the site positions him in the lineage of the 11th-century garden manual *Sakuteiki*, which prioritizes a locality's physical and social contexts. Absorbing these variables, Abe creates spaces not filled with objects but defined as positive intervals between objects animated through "balance, tension and dynamic energy."[1]

Abe's insistence on an artistic vision that finds connections is evident in his comments on the impact of the Shinwa Bank garden by architect Sei'ichi Shirai (1905–83). Shirai's potent mix of materialism and space were inspired by a fascination with Gothic architecture and neo-Kantian philosophy. Kant's idea of *a priori* experience led Shirai to use forms to evoke a spirit inspired by immediate engagement, not dependent on existing knowledge. Arguably, Abe's gardens, like most successful Japanese gardens, are premised on such assumed understanding. Thus, most gardens tell a tale that is not a symbolic narrative but an abstract visual story that flows through every element. For Abe, this coherent visual language makes the space both meaningful and comfortable.

Creating Balance, Building a Practice

Above Shin Abe creates gardens premised on abstract visual narratives. Photo courtesy of ZEN Associates.
Opposite Sei'ichi Shirai's spare courtyard garden inspired Abe to treat space as a dynamic form. Photo by Osamu Murai.

Shin Abe was born in 1951 in the small Kyushu town of Usuki, known for its 11th-century Buddhist stone sculpture. His father ran a manufacturing firm, the family business providing a model of entrepreneurship. At Tokyo University of Agriculture, Abe studied in the illustrious landscape architecture department founded by Keiji Uehara (1889–1981) and Takuma Tono. Though focusing on site planning and horticulture, he was exposed to Kenzō Ogata's naturalistic garden style. After graduating in 1974, Abe did maintenance and installation gardening for a developer in northern Kyushu, where he encountered the visionary architect Sei'ichi Shirai.

Determined to study Japan's garden traditions, Abe interned for two years in Kyoto with the famous garden maker and restorer Kinsaku Nakane. Assisting Nakane with drawings, Abe worked on projects for Japanese temples and in Jurong, Singapore. Impressed by Nakane's internationalism, Abe sought to study abroad. At the suggestion of Nakane's American student Julie Messervy, Abe applied to the Landscape Architecture program at Harvard's Graduate School of Design. Although he struggled with English and the orientation of many classes, Abe was impressed by Peter Walker's course on landscape architecture as art, an idea enforced by a campus visit from Isamu Noguchi, who showed his adaptations of Japanese gardens in sculptural courtyards using cut and natural stones.

Upon graduating in 1979, Abe had no intention of making Japanese gardens, yet clients seemed to expect them. In his first project, for the National Fire Protection Association office in Quincy, MA, he built a two-story waterfall that flowed from the indoor atrium out into an adjacent yard. There, Abe augmented the natural stone outcrops with black pines, Japanese maples and undulating clipped hedges reminiscent of Nakane's naturalistic gardens. When his visa expired during the project, Abe consulted an immigration lawyer who recommended that in his application for permanent residence Abe state that he would avoid taking work from American landscape architects by building only gardens in Japanese styles.

Although initially wary of this career move, when Abe saw Takuma Tono's successful adaptation of traditional styles at the Portland Japanese Garden and reflected on the ways in which sculptors Noguchi and Masayuki Nagare interpreted Japanese design principles, he decided to make the evolution of Japanese garden style his goal. He also thought he could help internationalize Japanese culture from the outside. Thus, in 1980 Abe decided to call his new firm ZEN Associates, borrowing the clipped gravitas of names like IBM and NEC, taking advantage of the American fascination with Zen Buddhism and indicating his own desire to evolve Japanese culture. Abe established the company's mission as realizing the client's dreams in the belief that "through the balance of art, science and nature, we can create spaces for living, learning, and growing."[2]

Based on Abe's optimistic vision, business acumen and design talent, aided from 1990 by business partner

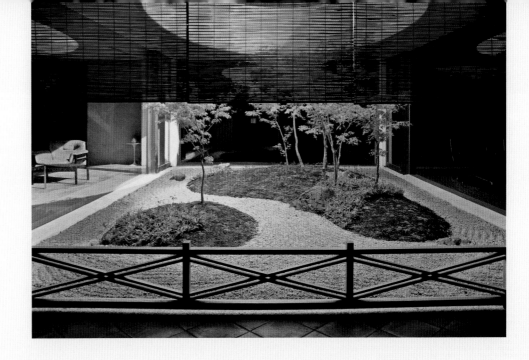

Peter J. White, the company's billings doubled almost every year. By 2015, ZEN Associates had over fifty employees in its Boston and Washington, DC offices devoted to the integration of landscape design, construction and maintenance. An interior design department headed by Abe's wife Maho pursues the connection of indoor and outdoor spaces.

ZEN Associates' portfolio is diverse. The firm restored Shōgo Myaida's Japanese garden at Marjorie Post's Hillwood estate, renovated Nakane's Tenshin-en at the Museum of Fine Arts, Boston, and planned the renovation of the Birmingham Botanical Garden's Japanese garden complex. Abe also created large traditional Japanese-style pond gardens at estates in West Hartford, CT and Granite Springs, NY. Exemplified by The Farm, a suburban condo complex in Chestnut Hill, MA, Abe has built naturalistic landscapes inspired by Japanese gardens. Most characteristic are his modernist adaptations, fitting into courtyards at Yale's Branford College, Amherst College and Showa University, Boston, and gracing the homes of Boston's tech billionaires.[3] These gardens evoke the auras of progress and polish desired by such élites, but at their best they also create balanced environments that can enhance living and encourage learning.

The Man Whose Work Influenced My Life

After graduating from college, I worked as a landscape designer at the Nagasaki branch of a developer. One day we received a call to consult with the Takenaka Construction Company on a landscape project at the Sasebo Shinwa Bank Headquarters, built by the famous architect Sei'ichi Shirai.

Arriving at the Sasebo Shinwa Bank building, it was magnificent with the heavy stones of a Gothic church. Shirai was a well-built old man with white beard and hair combed back, small round eyeglasses like John Lennon, and a gorgeous black suit with a thin black tie. His appearance impressed me as well as his downtown Tokyo dialect. He explained the plan for the courtyard cascade we were to construct. He then took me to the bank president's special office.

The room was very dark, with stone floors and walls. A beam of light illuminated the president's desk as if he were a medieval king on show. A small, flat courtyard faced the office through a large window. Illuminated from above by natural light, the garden had one meticulously pruned Japanese maple, a patch of moss and a small, flat rock. The space was filled with Shirakawa pebbles framed by a granite curb and black terrace tiles. I could feel Shirai's outstanding taste that seamlessly juxtaposed this simple garden with the heavy neo-Gothic interior of the room. I learned then the power of the positive void and the technique of contrasting elements. It has been forty years since I glimpsed this garden for the first and last time. Recently, I saw an image of it in a book but the garden had changed disappointingly.

Shin Abe

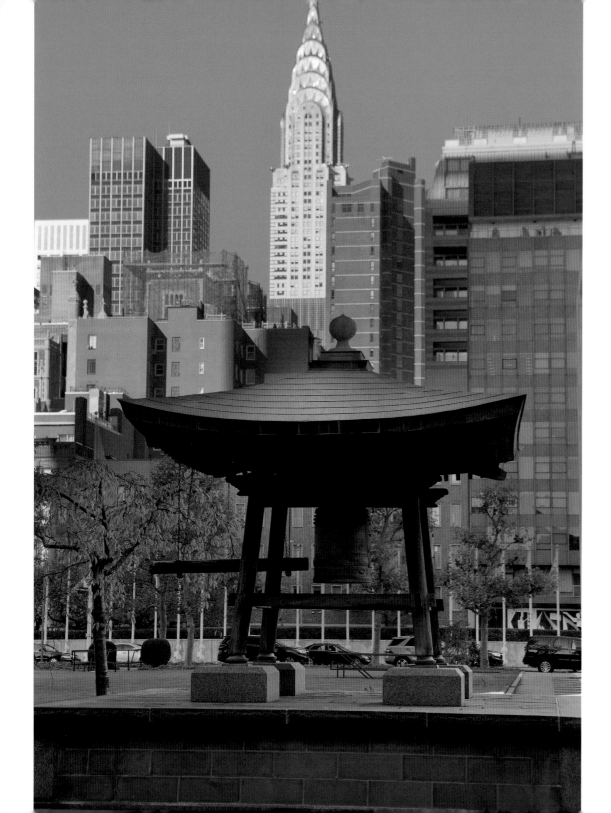

Reverberations:
The United Nations' Peace Bell Courtyard

In 1997, when cracks damaged the marble floor around the Peace Bell which had been gifted by the United Nations Association of Japan in 1954, the United Nations Secretariat asked the Japanese government to create a garden there. Motohide Yoshikawa, then minister to Japan's Mission to the United Nations, raised $500,000 and selected ZEN Associates because Abe's minimalist design seemed suited to a site beside Le Corbusier's iconic building and to the task of symbolizing peace enveloping the world. Completed in 2000, the garden was removed a dozen years later when the United Nations building underwent asbestos mitigation. The garden was renovated in 2015, reopening on Peace Day when the Secretary General rang the Peace Bell to affirm the ideals of the United Nations.[4]

Far left The Peace Bell platform of Pennsylvania bluestone harmonizes with Manhattan's midtown towers.
Left Bluestone reappears on the courtyard floor, where it meets Japanese creeping juniper.

Below Groves of Japanese maples and dwarf cherries echo the olive wreaths on the UN flag, while the shapes of the five continents are rendered with stones and low plants.

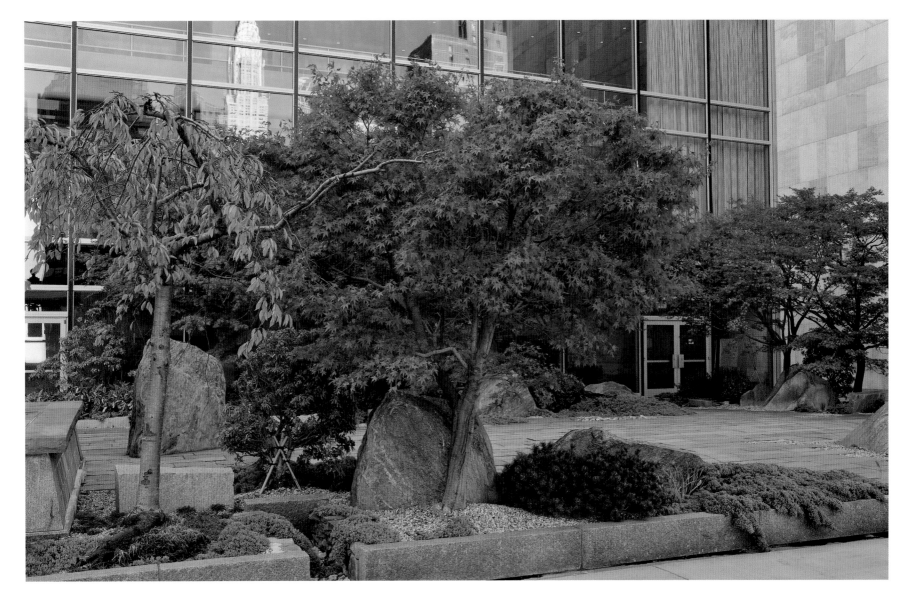

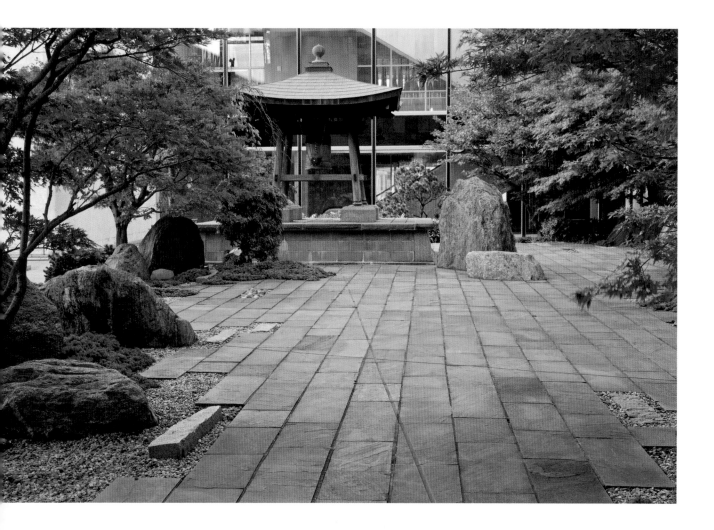

Below The Peace Bell was donated by the United Nations Association of Japan in 1954, two years before Japan was admitted to the UN. It was the idea of a former soldier, Chiyoji Nakagawa, who, aghast that Japan's temple bells had been melted down for armaments, started raising money for them. Attending a United Nations meeting in Paris in 1951, he thought to make a smaller bell for the UN out of coins from sixty member nations. The one-meter-high bell weighs 116 kg.

Above Through sight lines across the courtyard, Abe maintains focus on the Peace Bell. Next to it, the largest stone represents Mt Meru, the axis mundi in Buddhist cosmology. Because the court sits atop an underground room, the gneiss boulders could not be buried but had to be cut flat across the bottom taking into consideration their final height and angle.

Abe's brief was to create an engaging space for gathered dignitaries and to appeal visually to people walking to the Security Council Chambers. Asked to recall the UN flag's design of the oceans and continents seen from the North Pole, Abe imagined the bell, occupying the North Pole, ringing out peace across the world. Stones mark the five continents, with the largest stone representing Shumisen, the cosmic mountain of Buddhism. Groves of cherries and maples around the court restate the crossed olive branches of the UN flag. The trees soften the hard courtyard, evoke time through reference to spring and autumn when they come into color, and emphasize the garden's Japanese identity. Abe's design maintains focus on the rectilinear Peace Bell but shows its power reverberating into the world defined by organic forms.

Above The inscription reads "Long live absolute world peace." The Peace Bell is rung twice annually, at the vernal equinox on Earth Day and on September 21, the Day of Peace, by the Secretary General and President of the General Assembly to reaffirm the UN's mission.
Right The planting beds contain cherry and maple trees, Japanese andromeda and mugo pine for shrubs, and for ground cover sasa veitchii and dwarf mondo grass.

An Intimate Journey: The Garden Path at a Private Washington, DC Residence

Abe's skill in manipulating space is expressed in this narrow garden, about 10 feet wide and 100 feet long. Comprising a path linking a garage on the far side of one block with its house on the other, the garden is traversed by the owner going to and from his car. Because it provides a transition from the public world to the private realm of the home, Abe imagined it as a tea garden path, shutting out external views with a woven fence on one side and plantings on the other. Abe's balanced energy emerges in the contrast of sturdy lanterns, water basins and stones with the delicate mix of small and medium size shrubs beneath an overstory of Japanese maples. A low bamboo fence adds intimacy and ties together the space. Slightly offset rectangular paving stones create micro-jogs in the path and introduce subtle complexity. Near the path's center, Abe placed a gate and a bench; the sitting area breaks the garden into inner and outer areas and provides an area of visual focus and contemplation.

Left The walkway is composed of Pennsylvania bluestone with salvaged granite curbs and fieldstones. An area with small stones distinguishes the path beneath the fence.

Below The horizontal orientations of the path and Kinkakuji-style bamboo fence are balanced by the verticality of the lantern, tree trunks and fence posts.

Left Because the patron was a horticulture enthusiast, he requested diverse planting and Japanese species, including cryptomeria, Japanese maple, hinoki cypress, nandina, Japanese holly, aucuba, satsuki azalea, pittosporum, kamaria, Japanese painted fern and Japanese silver leaf.

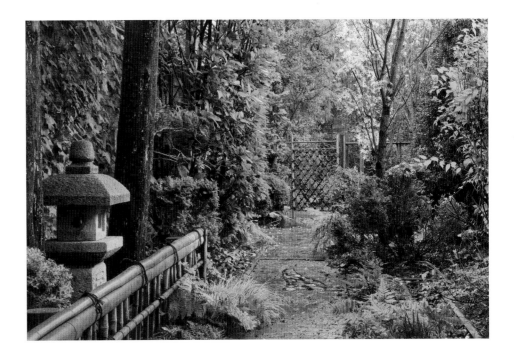

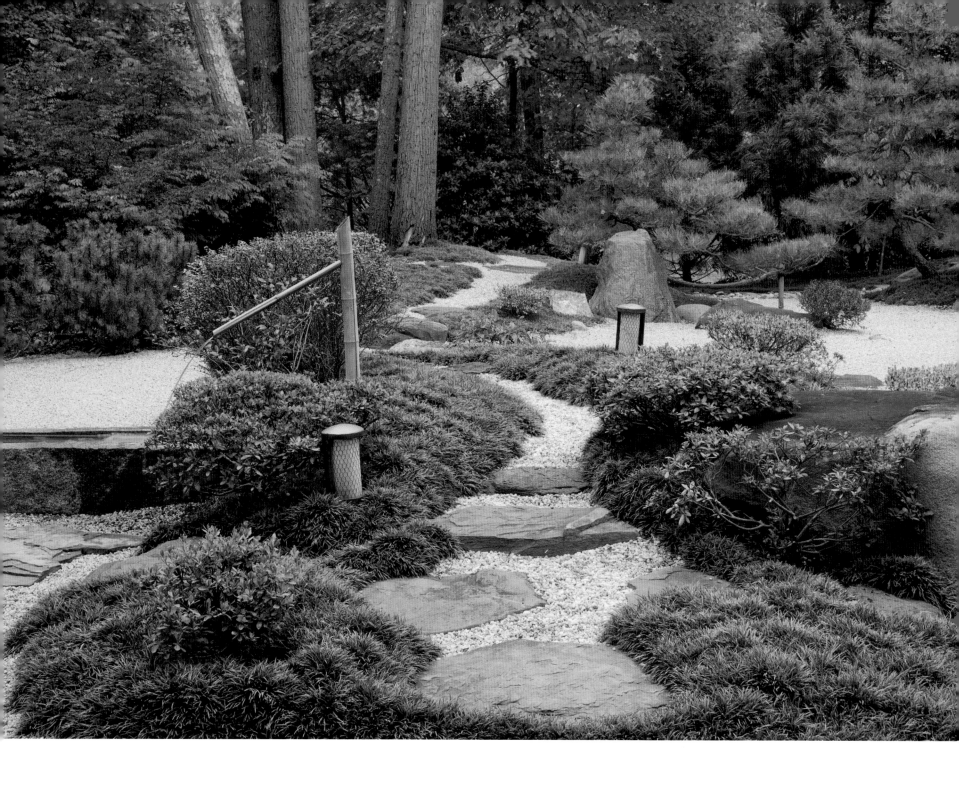

Inspiration
for Reflection:
Restorative Gardens
at the Stoner
Residence

One of Abe's most representative and impressive residential gardens embraces the waterside home of Kitty and Tom Stoner in Annapolis. The clients are committed to gardens as restorative environments through their TKF Foundation that creates green spaces in underserved areas in Baltimore, Washington and Annapolis.[5] As seen in the owners' statement on page 95, the garden reveals Abe's ability to nurture his client's vision for a retreat from the workaday world and as a stimulus to reflection. Built in four phases over a dozen years, the garden is maintained by ZEN Associates.

A series of linked zones in different levels of formality, the main area attracts the eye from various vantage points inside the house, serves as a visual extension of a patio area used for entertaining and may be toured along a strolling path over stepping stones and stone bridges. Largest and earliest is the dry landscape, or *karesansui,* that evokes a pond, raked to suggest ripples and traversed by a double-stone bridge. Abe abstractly

Left For all of its sculptural abstraction when viewed from house or patio, the garden features a path that skirts the dry ponds and climbs low forested hills dotted with ten black pines raised by Abe in his own yard.

Above The tied rocks indicate to visitors not to venture beyond this point.
Right New England field steppers serve as stepping stones. The boulders are gneiss, granite and schist fieldstones.

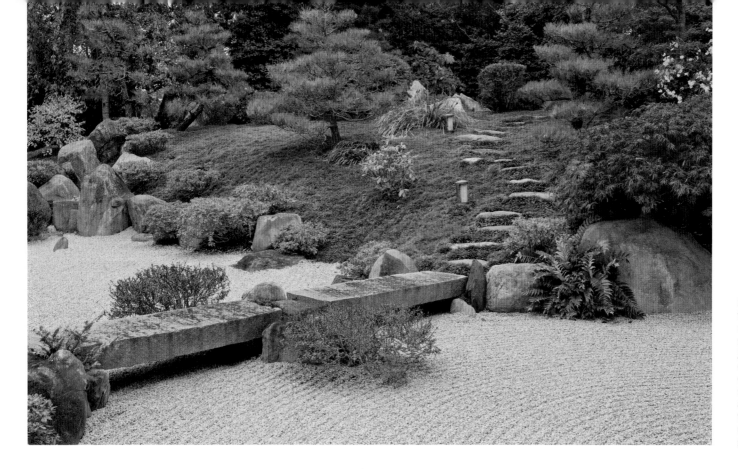

Left The verdant, vertical forest garden contrasts with the flat, white dry garden. Black pine, Japanese maple and cryptomeria form the overstory, Japanese spirea, satsuki azalea and barberry fill most of the mid-level and dwarf mondo grass covers the ground.

Above The garden journey includes quiet nooks to rest or contemplate.

mixes organic and geometric forms, contrasting dominant mineral tones against a verdant border. The garden also plays with textures, ranging from the fine grain of gravel and leaves of azalea, fern and maple to the polish of beach stones and the rough surface of large rocks. The abstract symbolism of the pond is broken by a long, rectangular water basin that introduces real water into the scene. The horizontal expanse of the dry garden is juxtaposed by a vertically oriented hillside forest garden leading to a patio balcony. Pines, small maples and other deciduous trees dot the hill, which allows views to the pond below.

The informality of the forest garden at far right and the semiformality of the dry garden in the center are set off by the formality of a small flagstone patio on the left side of the yard. The long horizontal bridge stones of the dry garden are referenced in slate gray slabs surmounted with small vertical stools. More intimate is the small walled courtyard garden, seen from a study and bedroom, where Abe arranges in miniature his trademark elements: clumping plants emerging from a bed of small stones set against elegant leafy maple raising above upthrusting horizontal stones.

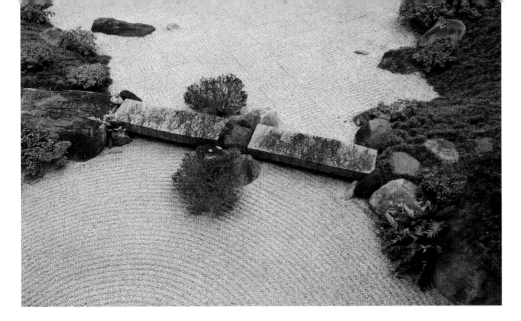

Above For the dry pond, Abe used crushed turkey grit granite instead of the Shirakawa sand utilized in Kyoto gardens.

Above right The total design of the property extends to the rear hill where rustic stepping stones lead over the hill to Chesapeake Bay.

Right The third garden space is a geometric patio composed of Pennsylvania bluestone slabs set in a running bond pattern, then decorated with small stools.

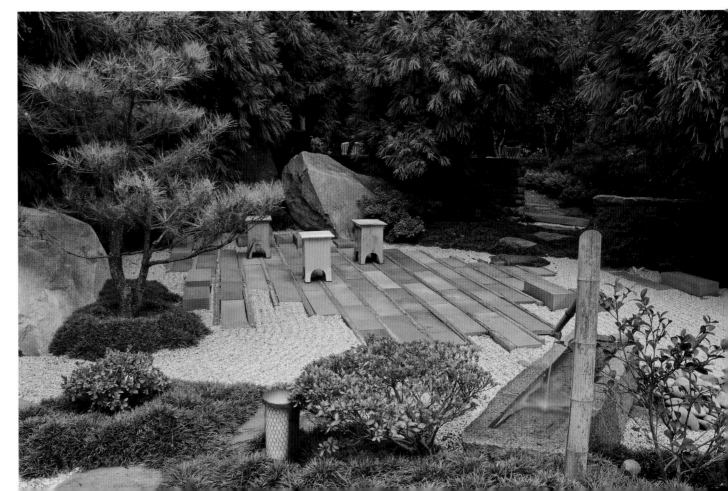

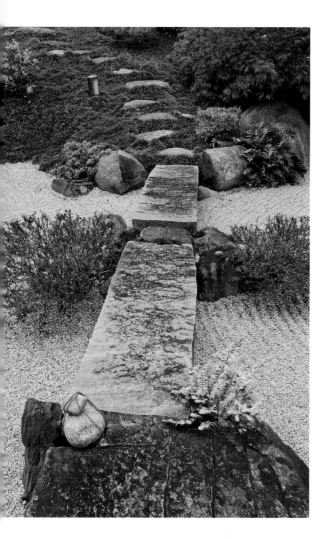

Abe's desire to give his clients a kind of spiritual journey is best seen in the paths and dry streams that pull one physically and mentally into the space. By curving around corners, the paths provide both order and provoke mystery. The variety of natural forms, textures and colors makes the garden dynamic without being busy.

Above The small Japanese bell at the residence's entry is rung by visitors to toll connection with the hosts. It hangs in a plinth designed by Jay Graham.
Right A densely planted hill screens the garden from the river behind the property.

A Japanese Garden as Sacred Space

After raising our family in an historic home in downtown Annapolis, we moved to the banks of Chesapeake Bay on an acre of land. We had traveled in Japan where we experienced the serenity and solace of Japanese gardens. Desiring a daily retreat from the cacophony of the business world and a place for reflection, we wanted to have a Zen-style garden on our property. Fortunately, at that time we visited Hillwood Gardens in Washington DC, which had recently been restored by Shin Abe and his team at ZEN Associates. We also went to see Shin's garden at the United Nations building and we became convinced that he could design and build the garden we dreamed of having surround our home. Shin Abe had the vision, creativity and expertise to make beautiful gardens in a variety of spaces.

A Japanese garden has a sense of mystery about it. It moves you into another world. This narrow space becomes an inspiration for reflection. A landscape creates a mood so you can look internally. In our garden, we believe this quality begins with the beauty and power of the placement of the selected stones. The work of our foundation (NatureSacred.org) centers on this same concept. We believe gardens and nature can heal.

Our garden has evolved in four phases over ten years. Shin Abe began with a dry water garden, then designed a forest garden that was connected by a path of abstract stones. He added a dynamic flagstone patio and a courtyard garden (*tsubo niwa*), viewed from both the master bedroom and a home office. We look forward to what might be the next phase of the garden. It is a spiritual process for us.

Kitty and Tom Stoner

On the Edge: Sculpting Water at the EF Building II, Cambridge, MA

Shin Abe's most committed client is surely Bertil Hult, head of EF (Education First) Ltd, the world's largest international education company founded in Sweden in 1965 to create "global citizens." In 2016, it employed about 40,000 people in 53 countries in language training and testing, educational exchange and travel and academic study. Abe built gardens at two of Hult's homes, the EF office in Stockholm and the first EF office in Cambridge, MA. There, ZEN Associates did the entire site plan, installing a pond, berm, high hedges and huge boulders that shelter the entrance from the street. Abe also introduced stone gardens to the lobby and 7th floor executive atrium, balancing benches pierced by artificial stones with Abe's signature offset stone slabs that decorate the floor and even hang in the air.

At the adjacent EF II building, the company's 10-story American headquarters finished in 2015, Abe's entry plaza garden responds to the drama of a "waterfall" that

Left The design highlights five multi-slab boulders composed of variegated Deer Isle granite, blue Chelmsford granite and black Virginia jet mist granite. These granite slabs are usually found on kitchen counters.

Above The falling and rising thrusts of the building and stone slabs are grounded by the wide plaza, its horizontality accentuated by the low granite rectangles that serve as benches.

Opposite In a setting where strong wind, little water and reflection from the glass tower would bake plants in the summer, Abe created a garden that fits aesthetically and biologically with the site.

Right The hard abstraction of the EF II building garden contrasts with the adjacent EF I building garden, where a small stream empties into a pool.
Below Semicircular courtyards flank the two sides of the plaza, the concrete walls containing the intense energy of the building and entry garden.

Right Composite boulders rise from abstract dry lakes composed of large, blackish aggregate stone and small washed gravel. These lakes hold islands defined by drought-tolerant lavender and gray santolina. From them grow Japanese black pine. In Abe's hands, such basic raw materials become elegant markers of complex space.

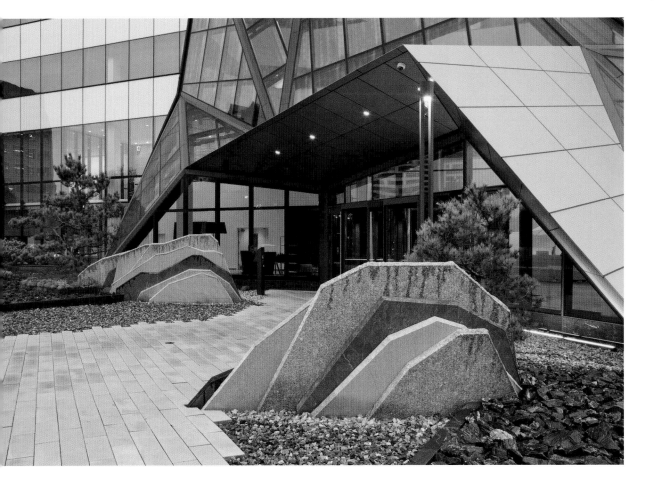

tumbles down the structure's main façade. Because the building is set between an elevated highway and the Charles River, architect Gert Wingardh sought to refer to those spaces through the steel and glass cascade that opens up the building to its surroundings. Abe had originally planned pools flanking the entrance to catch the "water" but replaced them with symbolic dry pools comprised of large beds of buff pebbles and black beach stones. Real water shoots up from hidden fountains,

pine trees grow on mounded islands and cut stone slabs pressed together suggest both frozen waves and rock islands reduced to their conceptual essence.[6] At either side of the entry, semicircular courts bookend the space and provide places to sit. Abe's elegant plaza stabilizes the tumult of the building, providing a dynamically balanced transitional space that is both firmly grounded and appropriately abstract.

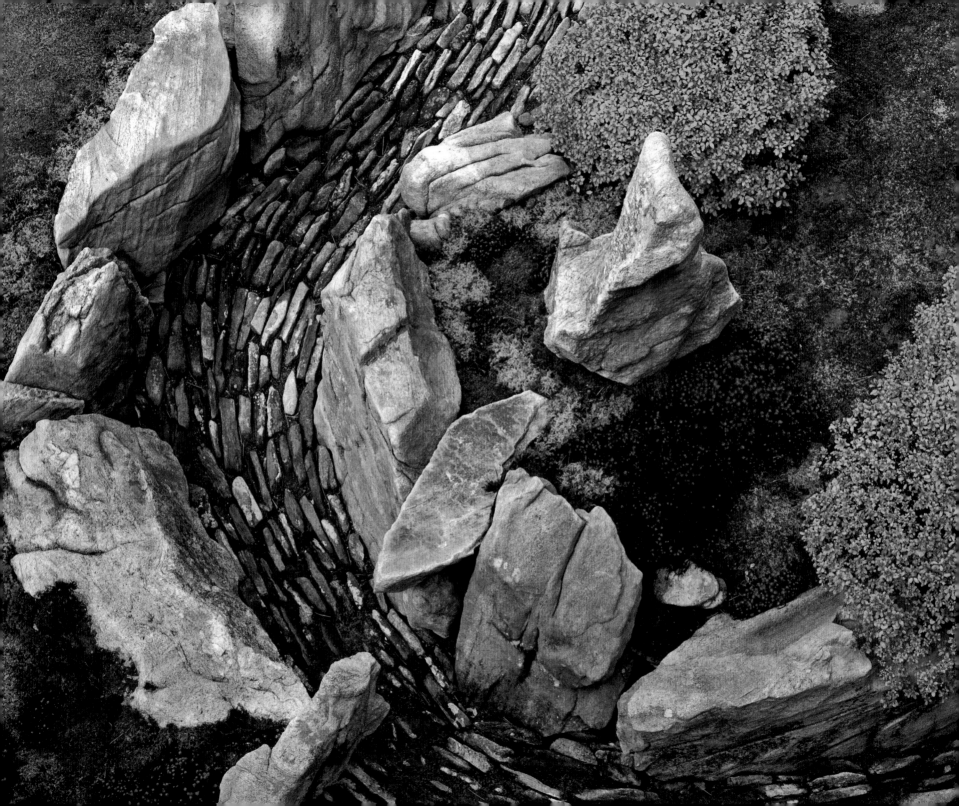

Garden Artistry: Marc Peter Keane's Reflections on Nature and Gardens

Garden historian, sculptor, essayist, installation artist, translator, furniture maker, storywriter, potter, poet, garden creator. Marc Peter Keane is an artist for whom gardens are compelling raw material and finely honed product. An American who has deeply imbibed Japanese culture, Keane seeks not simply to link the things of one place with the people of another. His art and writing aim to deepen experience by exploring intrinsic human connections with nature through gardens.

A major theme and mode in Keane's work is reflection. Gardens epitomize or reflect aspects of the natural world. As artful interpretative microcosms, gardens also allow us to reflect on our relation with nature in order to know ourselves more intimately. Keane designs gardens that focus perception through simplified form and organized space that may, in turn, expand conception by creating existential moments when thoughts turn inward. With garden and nature-based elements as his means, Keane's object is "meta-reflection" on our place and purpose in the world.

Keane embraces symbolism to give resonance to phenomena. Dynamic balance, for example, is a means of focusing attention on physical relationships *and* a metaphor for the harmony manifest in the complementary opposites of yin and yang. Asymmetry produces absolute balance and mitigates entropy by harnessing energy, but it requires the presence of a viewer who makes the energy real.

This deep investment in the implications of form is exemplified in borders that Keane sees as integral to understanding gardens. Boundaries enclose space (they make it "be"),[1] reduce scale and initiate intimate engagement. Yet, borders also create transitions and endorse unity by suggesting that the thing enclosed is associated with and stands for the thing outside it. The connection is made by the engaged viewer who activates the garden through response to its design. Unlike nature, which exists for itself, a garden demands human reflection.

The "Lives" of the Eminent Garden Artist

Marc Peter Keane was born in New York City in 1958 to a father who worked as a Hollywood cameraman then Manhattan executive and a Parisian mother active in fashion. Keane followed his father to Cornell, graduating in Landscape Architecture in 1979. He spent six years working as a graphic designer in Vermont, then briefly for landscape architect M. Paul Friedberg in New York. In 1985, Keane moved to Japan to study at Kyoto University's Department of Landscape Architecture. There, one year turned into eighteen. Keane did garden design for neo-traditional architect Ryōichi Kinoshita from 1988 to 1994. He then ran his own Kyoto design office from 1994 to 2002 while lecturing at the Kyoto University of Art and Design. Keane's embrace of Kyoto is evident in his essay on page 103 and in his efforts to preserve its urban heritage.[2] Keane returned to Cornell as a Halprin Fellow in Landscape Architecture from 2002 to 2003, though for a decade he led an annual intensive garden seminar at the Research Center for Japanese Garden Art in Kyoto. From his studio in Ithaca, New York, Keane writes, makes art and builds gardens.

Keane is well known to students of Japanese gardens through seven books: his elegant historical overview and primer, *Japanese Garden Design* (1996); with Jirō Takei, the translated and annotated *Sakuteiki: Visions of the Japanese Garden* (2001); an erudite history of *chanoyu* and gardens, *The Japanese Tea Garden* (2009); and a self-published exploration of garden-inspired Heian-period poetry, *Songs in the Garden* (2012). Keane offers philosophical and personal mediations on Japanese

Above Marc Peter Keane creates gardens that require and reward careful reflection. Photo by Don Freeman.
Opposite A characteristic Kyoto-style courtyard garden embodies how nature may be distilled to inspire human connection. Photo by Marc Keane.

gardens in *The Art of Setting Stones* (2002) and ruminates on our place in the world in the self-published *Dear Cloud* (2010). In *Moss: Stories from the Edge of Nature* (2015), Keane's nine short stories explore the subtle and surprising connections of nature and culture from Georgian England to contemporary Japan. Keane distills his profound and subtle knowledge in *Japanese Garden Notes: A Visual Guide to Elements and Design* (2016), a book intended for designers of all kinds.

Through his wife, the ceramicist Momoko Takeshita, Keane became fascinated with the potential of organic materials in works of art that distill nature into discrete forms.[3] In his ceramics, Keane coats grasses and leaves in clay, bends them into nests, then fires them for days. His tray gardens (termed *bontei*), assembled from found wood, stone and ceramic objects, arrange the patterns and forms of nature in bounded spaces. In Keane's so-called *ichimonji* benches, a horizontal slab of black walnut, like the single *kanji* stroke for the number "one," is inserted into a groove cut in a gneiss boulder, the abstract form juxtaposed with the natural one.

Keane's resonant merging of opposites marks his art installations. In 2000, he won the Grand Prize at the Kyoto Arts Festival for *Omega Point*, an installation in front of the 9th-century pagoda at the Daigoji temple. Complementing the tower's yang, Keane created a yin element—a sand mound formed into the Greek letter Omega and containing a circular pond. Keane's title refers to Pierre Teilhard de Chardin's idea of a "super consciousness" that transcends form and thought,

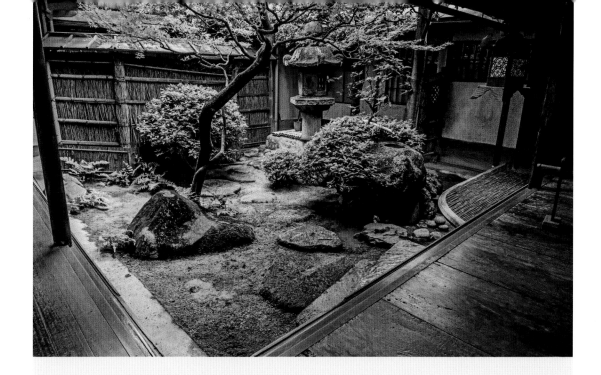

interpreting it in terms of global connectivity. The intersections of cultures, matter and consciousness also inform Keane's experimental teahouse, Arbor of the Three Wheels (*Miwa'an*), built with Cornell students in 2003–04. The spirit of connection implicit in the Buddhist metaphor of the Three Wheels (symbolizing giver, receiver and "that which is shared") is expressed in three intersecting arcs of wall that create the tearoom in their overlapping space. Made of local saplings, twigs and reeds, the temporary teahouse embodies the human connections to each other and to nature intrinsic to the *chanoyu* tea ceremony and to Keane's art.

Keane's finely tuned aesthetic sensibility and philosophical sensitivity are evident is his several private and public gardens in Japan. They are also fully expressed in his plan for the Six Friends Garden at Cornell Plantation.[4] In this bold, unbuilt project, Keane seeks to unite East Asian cultures and traditions of gardening, through six objects—stone, pine, willow, bamboo, lotus and Japanese maple—that signal specific virtues and aspects of human experience. The didacticism of the project points to Keane as a creative interpreter of Asian culture. It also signals his role as an educator who teaches and delights through lectures, books, art objects and gardens that reflect the human–nature dynamic.

The Essence of Nature Within the City

It was the summer of 1985. Kyoto. The first night of the Gion Matsuri. Visitors packed the narrow streets of Nakagyōku, hoping to see the household treasures that had been put on display in the old wooden townhouses. To allow passersby to see inside, the wooden lattices along the street and the paper doors from all the first-floor rooms had been removed so that people on the street could see right through the entire townhouse.

Looking in, first there was a room that was normally used as a shop. Beyond that was a small garden. Just a postage stamp of green. A stone lantern. A lady palm. Not much else. Beyond that was the room where the family of the house lived, and even further back was another garden, this one larger than the first, with some small trees and a tall water basin along the verandah. At the very back of the property, the white-plastered wall of the *kura* storehouse closed the view.

The small courtyard gardens found in Japanese townhouses, shops and temples, called *tsubo-niwa* or in some cases *senzai*, are distilled essences of nature, dropped within the architecture itself. When it rains, it rains inside the home. When it snows, it snows in the temple. When the wind blows, the shadows of fluttering leaves tickle the floors of nearby rooms. Nature is not something out there, it is within. Close at hand. Audible, touchable, immediate to the lives of the people who call the place home.

Marc Peter Keane

Gardens as Journeys: The B Residence, Darien, CT

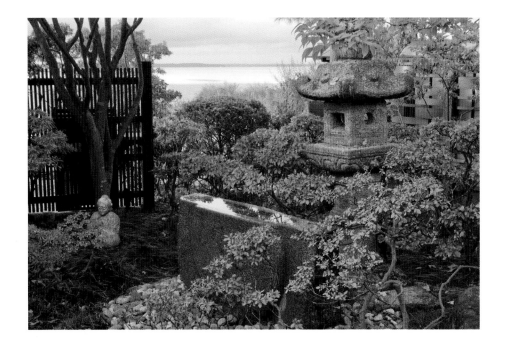

Before his return to New York, Keane's first American project was to make over the drab driveway and yard of a couple who collect Asian art and create garden art. This evolving body of work includes outdoor stone sculptures as well as miniature landscapes they make in stone troughs. Around the house, which sits on a picturesque promontory, Keane exposed natural granite outcrops to form the bones of the garden. He made new boundaries, softened others and added gates, fences and stones to energize the space. In sum, Keane created the garden as a unifying journey, part tea garden, part stroll garden, through a series of linked pocket gardens that provide a sense of discovery.[5]

Behind the house is a relatively formal courtyard garden. A wood and cut stone patio leads to a water basin and lantern that pull the eye to the ocean, past an elegant fence of thinly plaited and woven slats. In front of the house, a path through the hill garden culminates

A fence of rounded natural cedar poles encloses a space to contemplate a small Buddha statue from the owners' collection.

in the enclosed Buddha court. Another path leads through a grass garden. From the sweeping entry drive, the property's east side runs down to Long Island Sound. The vista is interrupted by a latticed gate with a circular design which allows partial views of a zig-zag bridge that crosses a marsh to a small island.

Right Keane, still living in Kyoto when making the garden, brought antique granite pieces from the old streetcar system to make the path.

Above A natural fieldstone path flows like a dry stream through a field of native grass.
Left Made with cedar poles and white oak carved with a *naguri* adze finish, this fence alludes to the familiar *yotsume*-gaki bamboo fence design.

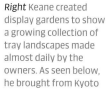

Right Keane created display gardens to show a growing collection of tray landscapes made almost daily by the owners. As seen below, he brought from Kyoto long granite foundation stones of demolished townhouses, then arranged them in steps. The path leads to the circular Buddha court.

Left Seen from above, an antique granite water basin is situated on an entry path for a cleansing function, like the *chōzubachi* basin in a tea garden.

Below The flourishing tray landscapes signal the garden's story of growth that began when the owners first met Keane in Kyoto.

Above The aged granite paving slabs from Kyoto establish an elegant ground pattern that resonates with other design elements.

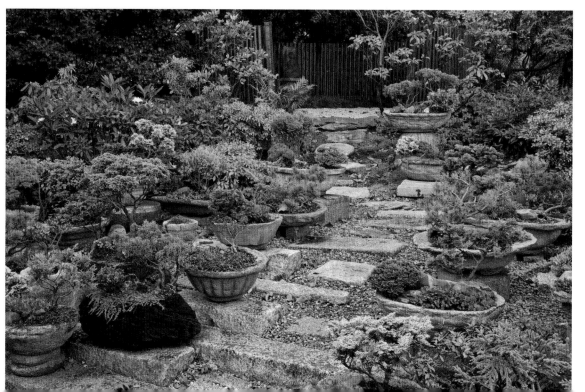

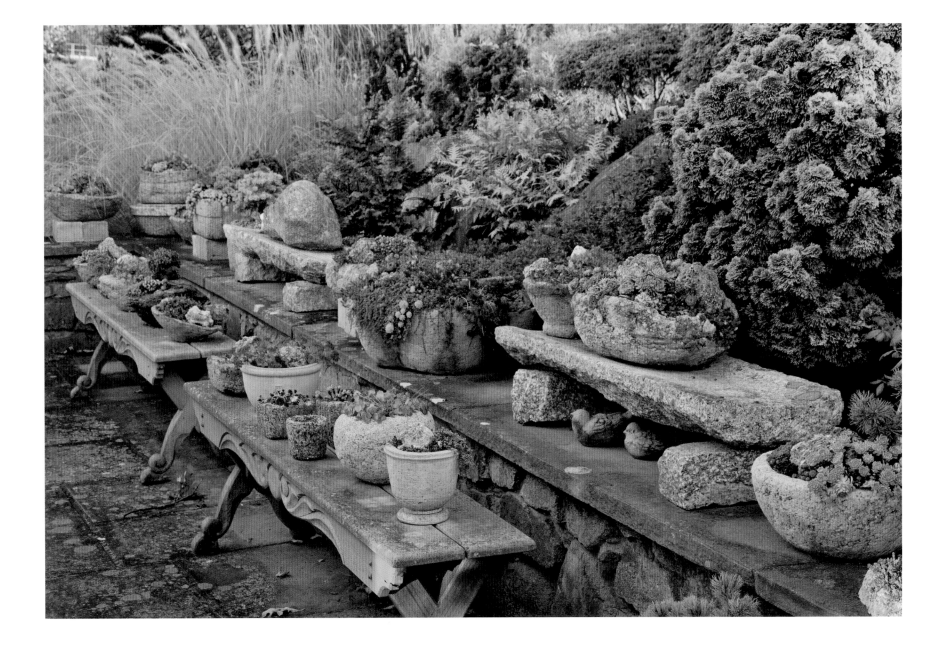

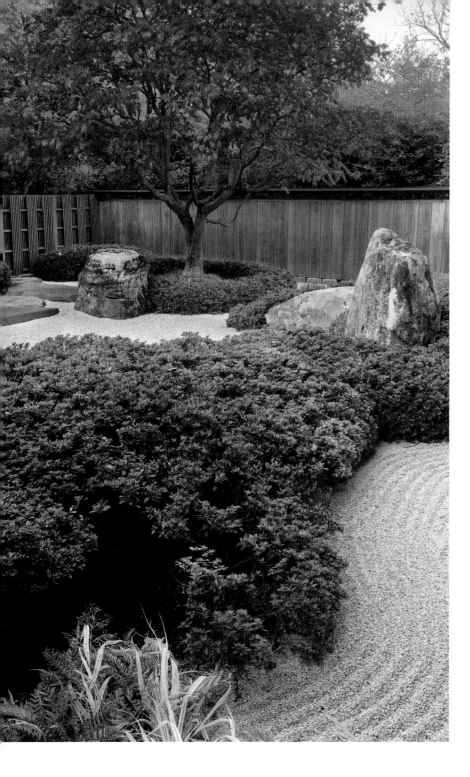

Forest-Ocean Garden: The Blum Residence, Irvington, NY

This two-part garden both links and divides the intimate, transitional space between the house and studio of a couple who collect contemporary art. One need not exit the house to find a dynamic distillation of nature. A door in the painting-filled living room opens to a kinetic garden sculpture, where water drops from an oak spout to a carved stone basin, then spills into a bed of beach stones, its ripples spreading through concentric rings of a stone border and a scrim of plants.

To access the studio from the house, one crosses a patio and enters the Forest Walk garden. Adapting the form of a tea garden, stepping stones lead through a small forest of boulders set among ferns and azaleas under a canopy provided by a cherry and Japanese maple. From the studio door, a narrow courtyard of small stones and great slabs creates one shore of the Ocean Garden. On the west side, a fence and bamboo grove screens the road, while the densely textured wood and stone façade of the house forms the near wall. The garden consists of an ocean of raked white gravel

Above The water basin, placed outside a living room door, was carved from a gneiss boulder. The long spout is white oak.

Left The undulating contours of the gravel ocean shore, clipped azalea and large blue-stones create a fluid world of curving forms set within the rectilinear confines of the house and fence. Made of knotless cypress, the fence opens to reveal a bamboo grove.

Right The tight micro-cosmic focus brings out the symphony of textures present in the chicken grit gravel sea, azalea hedge, gneiss boulders, wood siding and fireplace stone.

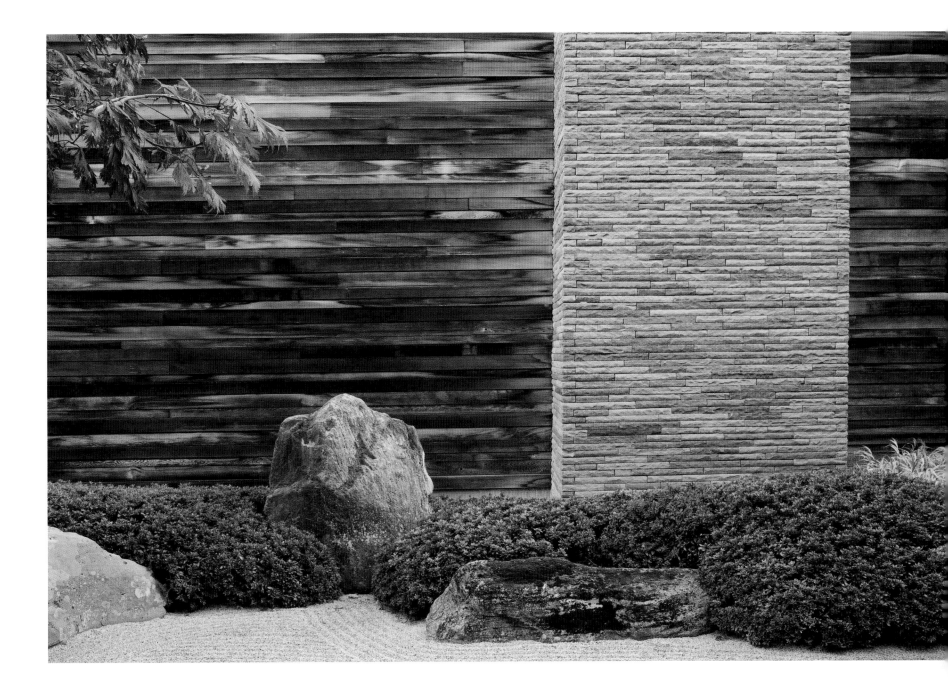

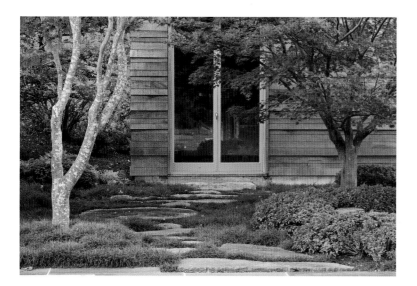

Right Set among ferns in the forest garden, a naturally curved piece of bluestone forms a bridge.
Opposite The garden effectively evokes the ocean in its rippled surface, its sense of agelessness suggested by the stones and the eternal flux of the blooming and falling azalea flowers. Kyoto-trained gardener Asher Browne has kept the garden in superb condition.

Above The forest walk, adapting the mindful stroll through a tea garden, reaches the studio between a Japanese maple and a Japanese snowbell.

Right The journey from the patio and house to the studio and dry garden is over huge bluestone stepping stones set in dwarf and standard mondo grass.

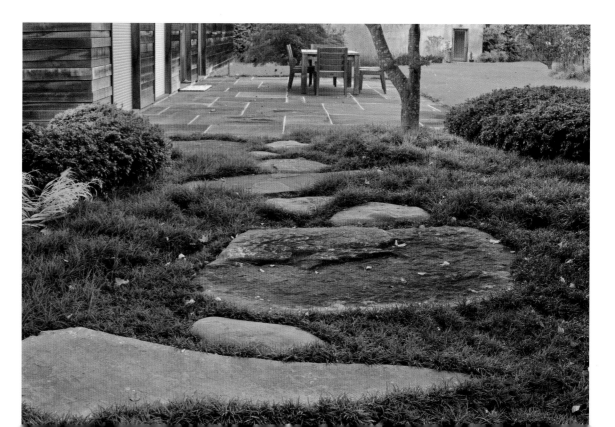

bordered by horizontal and vertical boulders that emerge from tightly clipped azalea hedges. The reduction of elements focuses attention on complementary tones and textures as well as compositional balance, so that the garden becomes a sea of deepening calm. Keane controls the transition from the Forest to the Ocean by hanging a bench on the studio wall. The bench forces the visitor to pause, invites him to sit. The garden then compels the visitor to ponder.

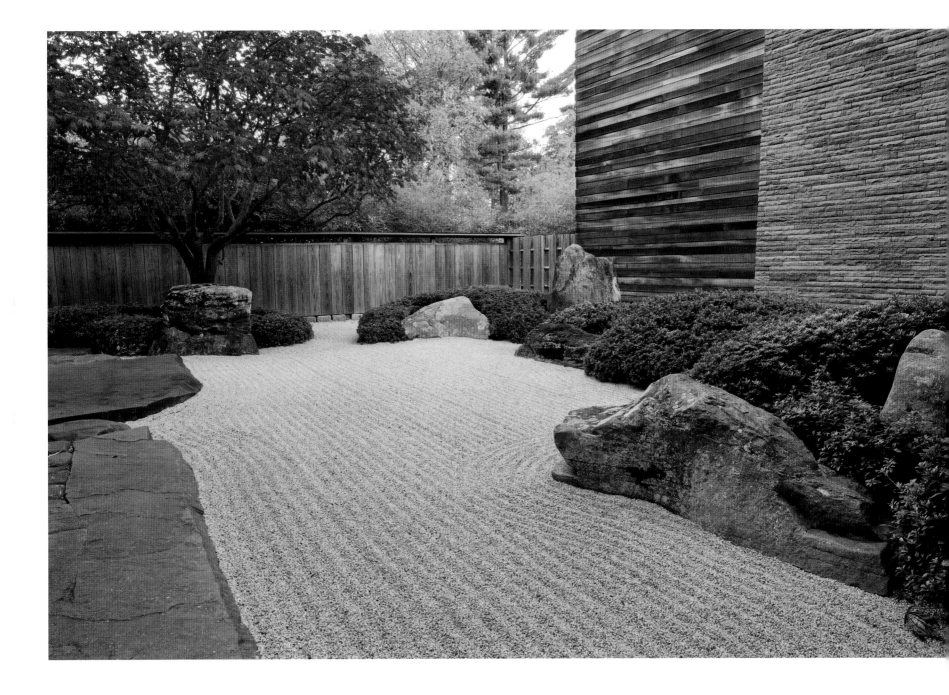

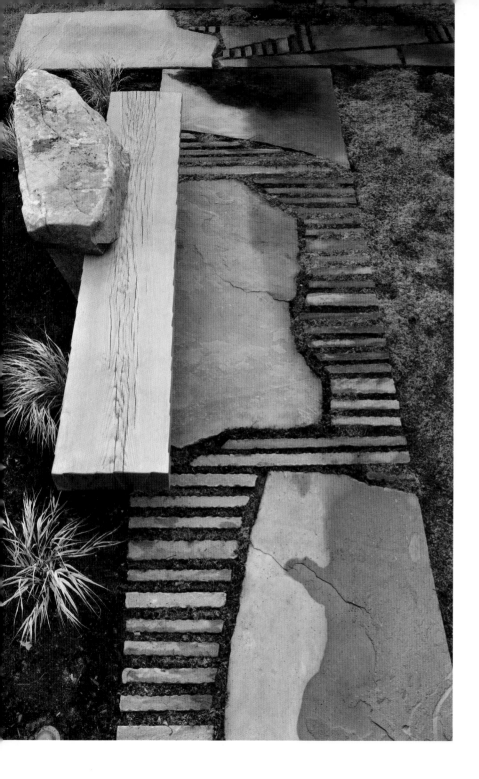

Dream Islands:
The Z Residence, Stone Ridge, New York

Keane's creation of microcosms that both mark and erase borders between gardens and nature defines the Dream Islands Garden. Completed in 2015 at the country home of a New York-based photographer and curator invested in the natural world and in minimalist form, the rectangular garden activates the space between a modernist guest house and a hill leading into a Catskills' forest. The garden is comprised of five local bluestone boulders set in a rectangular bed of moss. A stone wall divides the garden from the planted hill, although a stone stairway from the garden cleaves the wall, ascends the hill and leads to the forest.

The garden's left edge is formed by a wooden deck, while the right border is composed of a walkway of stone slabs and stones on edge, punctuated by an *ichimonji* bench. The garden is seen directly from the house's sunken bath, across an interstitial *nobedan* path of the

Above Dream Islands refers to the Buddhist idea that existence is a dream, fragile and always changing—like a fern growing on a stone.
Left An *ichimonji* bench and path define one side of the garden.
Right An opening in the stone wall around the fire pit focuses the view into the forest. The large standing stone points the way to the Dream Islands garden behind the guest house.

Above Glimpsed through a guest house window, the stones and stairs leading from the garden provide an orderly, axial orientation that dissolves in the forest's chaos.

same local sandstone. Reductive in the extreme, the garden is an invitation to inspection and introspection. The stones are the yang component—solid, upright, eternal mountains. The moss is the yin element—soft, fluid, supine water. Together nature is encapsulated. Yet, the garden is not reduced to a simple binary. The stones, standing and recumbent, are mottled and fissured, sprouting ferns and grasses. The moss, too, is a micro environment of countless colors and textures.

Right In the modernist guest house designed by Leven Betts Studio, a large glass window looks from a sunken Japanese-style bath into the garden so that bathers have a ground-level view of the garden.

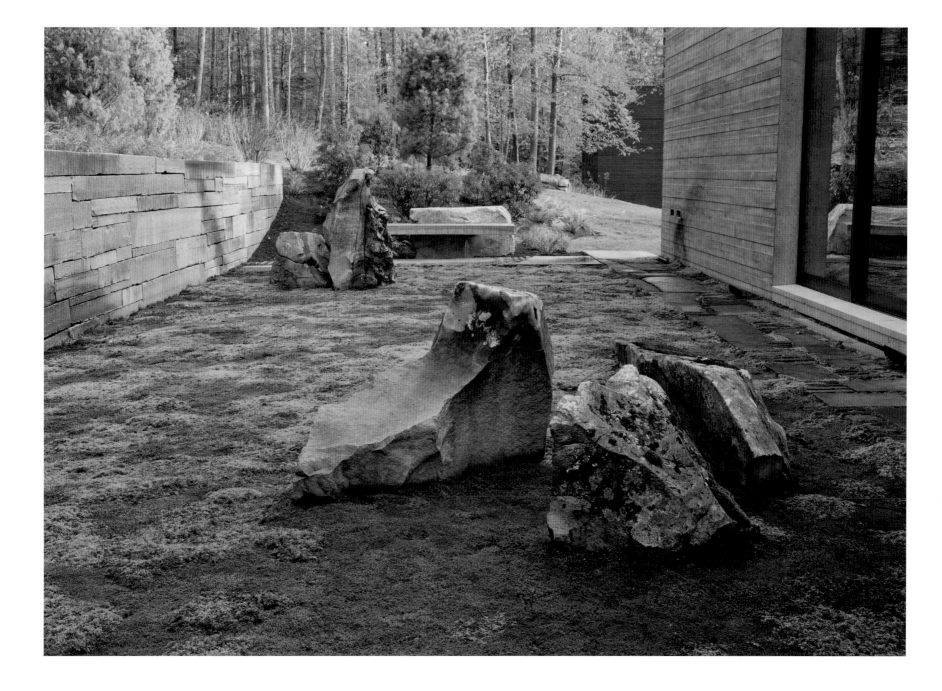

Left Six varieties of moss fill the gaps between striated pavers in the walkways.
Right The garden stones were gathered from around the property for their sculptural qualities.

Left The wall, made of long, sturdy slabs of bluestone, opens for a stairway.
Opposite Keane inserted a large oak slab into a boulder to form a simple *ichimonji* bench.

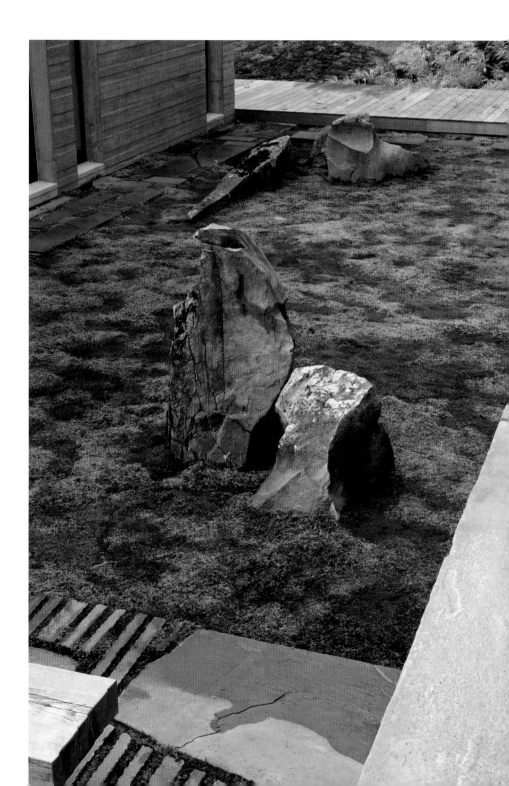

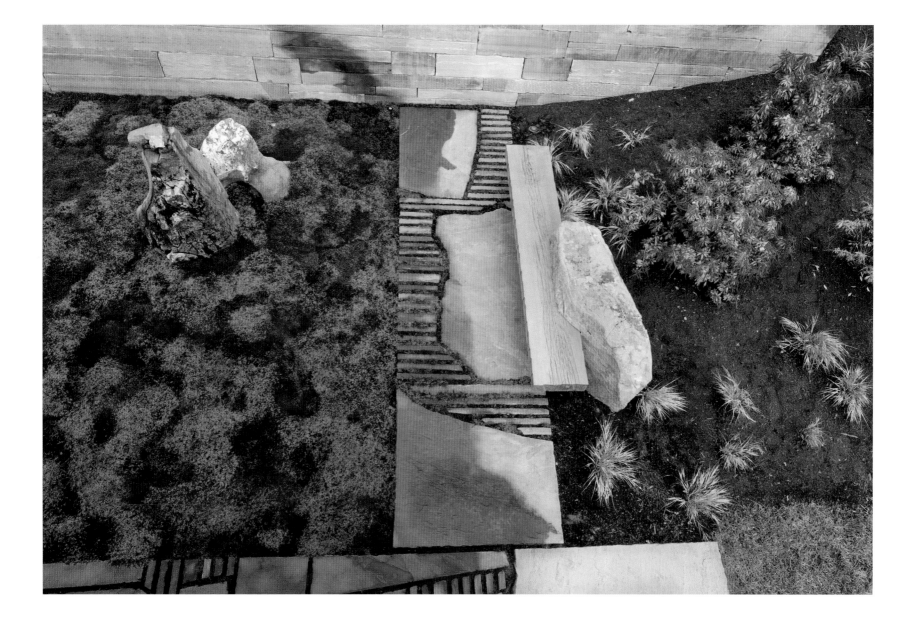

At Tiger Glen Garden:
Herbert F. Johnson Museum of Art, Cornell University

Keane's only public garden thus far is arguably his most compelling work. Commissioned for a corner space outside the art museum's new wing, built in 2011, the garden has Keane's signature containment, tight focus and gentle intensity. Made to be seen from inside or outside the building, the garden is both fitted into the museum space and fitting for it, as former director Frank Robinson explains on page 123. Like installation art, Keane made drawings, arranged and "edited" the stones at the Connecticut quarry where he acquired them, then reassembled the work on site.

The garden refers to the famous Japanese painting subject, the Three Laughers of the Tiger Ravine. The theme is a parable of bridging sectarian differences to achieve a transcendent understanding of the world. Three men—representing Buddhism, Confucianism and Daoism—met at a mountaintop temple from which the Buddhist monk Huiyuan had vowed never to leave. However, when lost in conversation with his Daoist friend Lu Xiujing and the Confucian poet Tao Yuanming, Huiyuan crossed the ravine that marked the temple's boundary. All three laughed at the absurdity

Left The only actual water in the garden flows into this basin made from a gneiss boulder carved to Keane's instructions. **Right** The garden is compelling from inside the museum or the bench-lined wooden deck. It can also be seen from a roof deck.

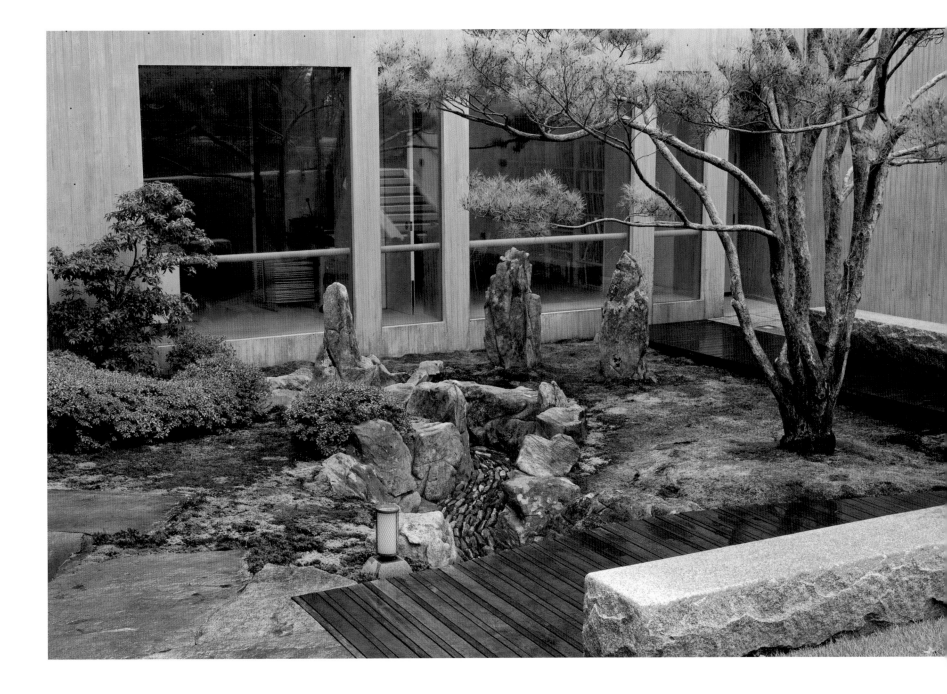

of such self-imposed limits. In Keane's design, three vertical boulders suggest the three men above the undulating ravine that animates the garden. Rushing water in the defile is implied through the stones at its bottom. The only actual water in the garden flows into a stone basin. The Three Laughers theme suits a university on a hillside campus flanked by water-filled canyons and where finding deeper truths is the larger goal.

Thanks to a Cornell bryologist, Keane discovered that his moss carpet, in fact, contained 12 moss species. That

introduction to moss impelled Keane to explore the wonder of the world's oldest land plant. Moss is the subject of the first tale in Keane's book of short stories. The care required to keep moss alive and attractive in central New York pushed Keane to create a friends group for the Tiger Glen Garden. These volunteers clean, water and connect with the moss, and each other, in ways that would surely impress the original three laughers.[6]

Above The three large, vertical stones play the roles of the three Chinese sages whose realization is an ecumenical parable about the folly of arbitrary distinctions.
Right In the dry stream, the arrangement of small, weathered stones set on end evokes the feeling of running water.

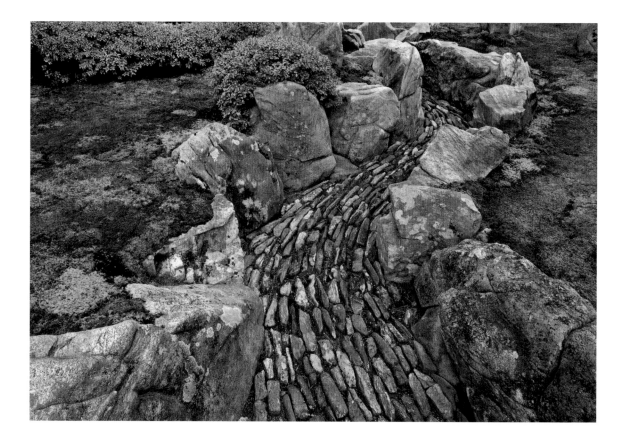

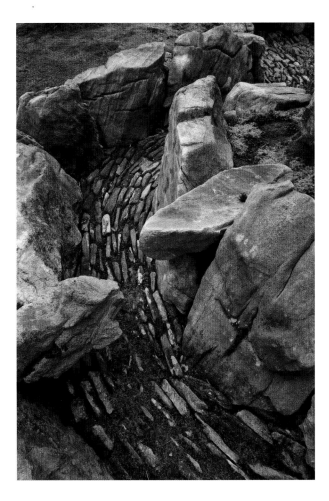

Above Two horizontal stones suggest a bridge over the deep gorge, a motif with local resonance in a town that proclaims "Ithaca is gorgeous."
Above right The Tanyosho pine shows the multiple trunks that distinguish this type of red pine.

An Art Museum Garden

The Tiger Glen Garden is one of the most exciting additions to the Cornell campus. Marc was crucial at every stage, attentive to each detail, patient in explaining his aesthetic decisions and the philosophical lessons inherent in the theme of the three figures and three religions embodied in the garden. We are proud that those lessons are at the core of this, and every, university.

There were many reasons why this garden was important for the museum. First, Cornell has long had a close relationship with East Asia. Second, the high point of the museum is our Asian collection. Third, landscape history and design are actively taught at Cornell. The museum, and Cornell, would be incomplete without making a living example of this great Asian art accessible to our students and visitors. The core of every museum is education, and self-education, and this mission is superbly exemplified by the garden's iconography.

The museum and garden are also a haven where we can think about what is important in life, encounter the values of other times and places, and thus better understand our own values. The garden is a delight not just for the museum's visitors but, since it is accessible at all times, to many people who come for a quick glance or to settle on the stone seats, absorb the beauty of this quiet place and regain their spiritual equilibrium.

Marc was especially helpful in talking to our generous donors, Rebecca Q. and James C. Morgan, and in finding and motivating volunteers to maintain the garden. We were fortunate that he and his wife Momoko, also a gifted artist, live in the same town. Often Marc can be discovered on hands and knees working to keep this special treasure as beautiful as when it was first created.

Frank Robinson, Director of the Herbert F. Johnson Museum of Art (1992–2011)

Endnotes

Introduction Notes

1. Shiota's ideas are best glimpsed in the booklet he authored, *The Miniature Japanese Landscape: A Short Description* (Newark: Newark Museum Association, 1915). Kubota's life and work are discussed in Anna Tamura, "Gardens Below the Watchtower: Gardens and Meaning in World War II Japanese American Incarceration Camps," *Landscape Journal* 23: 1 (2004). For Myaida's life and ideology, see Kendall Brown, "The Japanese-style Garden at Hillwood," *Antiques* CLXIII: 3 (March 2003).

2. Kaneji Dōmoto and George Kay, *Bonsai and the Japanese Garden: Applying the Ancient Bonsai Art and Japanese Landscaping to American Gardens* (Barrington, IL: Countryside Books, 1974).

3. The public gardens by these figures are discussed in *Quiet Beauty* and Makoto Suzuki, ed., *Japanese Gardens Outside Japan* (Tokyo: Japanese Institute of Landscape Architecture, 2007). See also Bradford McKee, *The Gardens of Ron Herman* (Washington: Grayson, 2012) and Julie Messervy, *The Inward Garden: Creating a Place of Beauty and Meaning* (NY: Little, Brown, 1995). For Masuno, who has created gardens in Canada and Europe, see Mira Locher, *Zen Gardens: The Complete Works of Shunmyo Masuno* (Rutland, VT: Tuttle, 2012).

4. Newsom's stay in Japan and such publications as *Japanese Garden Construction* (Dōmoto, Kumagawa and Perkins, 1939) were subsidized by Japan's government. His papers are at the Loeb Library, Harvard. Furlong describes his award-winning work in "Garden of One Hundred Stones: Contemporary American Conception in the Japanese Style," in *Landscape Architecture* (October 1952). For Gong, see Lisa Parramore, *Living with Japanese Gardens* (Salt Lake City: Gibbs Smith, 2007). Other residential gardens are featured in such books as Peggy Rao and Jean Mahoney, *Nature on View: Home and Gardens Inspired by Japan* (Tokyo and New York: Shufunotomo/Weatherhill, 1993). Articles on building Japanese gardens in North America by Morrell, Kawana and others are found in Claire Sawyers, ed., "Japanese Gardens," special edition of the *Plants and Gardens Brooklyn Botanic Gardens Record* 41: 3 (1990).

5. Thomas Kirchner, trans., *Dialogues in a Dream: The Life and Teaching of Musō Soseki* (New York: Simon and Schuster, 2015). The great Zen priest was linking gardens with the practice of Zen through activities that engage the total self. In this regard, see J. Murungi, "Gardening at a Japanese Garden," in Gary Backhaus and John Murungi, eds., *Symbolic Landscapes* (New York: Springer, 2009) 305–21.

6. The Bowyers annual Christmas letter features the changes to their garden, and the card a garden-inspired *haiku*. The 2015 card read: "Ancient temple bell/Moss-rock, water, bending pine/Garden art . . . life art." For an irreverent account of creating a residential garden, see Keiran Egan, *Building My Zen Garden* (Boston: Houghton Mifflin, 2000).

7. Recent examples include Motomi Oguchi, *Create Your Own Japanese Garden* (Tokyo: Kodansha International, 2007), Peter Chan, *Creating a Japanese Garden* (London: PRC, 2003), Robert Ketchell, *Japanese Gardens in a Weekend* (New York: Sterling, 2001) and Yoko Kawaguchi, *Serene Gardens: Creating Japanese Design and Detail in the Western Garden* (North Pomfret, VT: Trafalgar Square, n.d.). There are also two classic books by Katsuo Saitō, *Japanese Gardening Hints* (Tokyo: JPT, 1969) and *Magic of Trees and Stones: Secrets of Japanese Gardening* (Tokyo: JPT,1964). All of these books illustrate numerous modern residential and commercial gardens.

8. Graham Hardman, "The Garden of a Thousand Views" (*Miharashi-tei*): The Garden at Bury Hospice," *Shakkei* 20: 4 (Spring 2014). JGA projects are recorded at jgs.org.uk

9. Kató's ideas are clarified on the company's website, ueyakato.jp

10. Another poem, reflecting the real work involved, reads: "Too many catkins/needles and leaves/where's my Hoover." O'Brien was inspired by Robin Kimmerer's book, *Gathering Moss: A Natural and Cultural History of Mosses* (Corvalis: Oregon State University Press, 2003). See also Marc Keane, *Moss: Stories from the Edge of Nature* (Ithaca, NY: MPK Books, 2015).

11. Martin McKellar and Andrew R. Deane, "Pushing the Line: A Theoretical Approach to Raking a Karesansui Garden," posted at japanesegardening.org on August 9, 2015.

12. Interview, August 12, 2015. For the Storrier Stearns Japanese Garden, see Christy Hobart, "A Serene Garden Reawakens," *Los Angeles Times* E9, April 6, 2013.

13. Richard Neutra, "Foreword," in David Engel, *Japanese Gardens for Today* (Tokyo and Rutland, VT: Tuttle, 1959) xiii.

14. For some research done by Fujii, see Mohamed El Sadek et al., "Brain Activity and Emotional Responses of the Japanese People Toward Trees Pruned Using Sukashi Technique," *International Journal of Agriculture, Environment and Biotechnology* 6: 3 (2013). For Goto's research, see "The Healing Effects of Japanese Gardens," in Seiko Goto and Takahiro Naka, *Japanese Gardens: Symbolism and Design* (London, Routledge, 2015) 146–56. This work expands on that of Roger Ulrich measuring responses of hospital patients to urban and natural environments. In *The Creation: An Appeal to Save Life on Earth* (New York: Norton, 2006)), Edward O. Wilson writes that "subjects in choice tests" prefer trees with divided leaves on low, horizontal branches, concluding, "It is probably not a coincidence that some people,

I among them, consider the Japanese maple the world's most beautiful tree," 66.

15. Rachel Kaplan and Stephen Kaplan, *The Experience of Nature: A Psychological Perspective* (Cambridge University Press, 1989), 57.

16. *The Experience of Nature*, 193.

17. In another study, they describe the excellent microcosmic quality of Japanese gardens, together with their implicit mystery through indirect views, concluding "Many of these concepts are useful to consider in creating environments that are restorative." See Rachel Kaplan, Stephen Kaplan and Robert Ryan, *With People in Mind: Design and Management of Everyday Nature* (Washington: Island Press, 2007), 72.

18. See Charles K. Sadler, "Design Guidelines for Effective Hospice Gardens Using Japanese Garden Principles" (MA thesis, SUNY Syracuse, 2007), and Martin Mosko and Alxe Noden, *Landscape as Spirit: Creating a Contemplative Garden* (Boston: Weatherhill, 2003). The exclusion of Japanese gardens from the discussion of healing gardens is evident in their absence from such studies as Nancy Gerlach-Spriggs, Richard Kaufman and Sam Bass Warner, *Restorative Gardens: The Healing Landscape* (New Haven: Yale, 1998), Clare Marcus and Marni Barnes, eds., *Healing Gardens: Therapeutic Benefits and Designs* (Wiley, 1999), Esther Sternberg, *Healing Spaces: The Science and Places of Well-Being* (Cambridge, MA: Belknap, 2013) and Clare Cooper-Marcus and Naomi Sachs, *Therapeutic Landscapes: An Evidence-Based Approach to Design* (Hoboken, NJ: Wiley, 2013).

19. Ruth McCaffrey, Clare Hanson and William McCaffrey, "Garden Walking for Depression: A Research Report," *Holistic Nursing Practice* (September/October 2010). McCaffrey and the Morikami offered the program to the public for a fee, and with financial support from Astellas Pharma USA provided the program free to over two dozen geriatric groups with mental and physical challenges. Responses were consistently positive and as of this writing the program has been adapted by the Bloedel Preserve and Yume Garden. For reports on the Stroll at the Morikami, Bloedel, Yume and San Diego Friendship Garden, see *Journal of the North American Japanese Garden Association* 4 (2107).

20. Michael Fowler "Hearing Shakkei: The Semiotics of the Audible in a Japanese Stroll Garden," *Semiotica* 197 (November 2012), and "The Taxonomy of a Japanese Stroll Garden: An Ontological Investigation Using Formal Concept Analysis," *Axiomathes* 23: 1 (February 2013).

21. Garrett Eckbo, *Landscapes for Living* (New York: Duell, Sloan, Pearce, 1950) 17–18. In the words of Le Corbusier, Eckbo states "Styles are a lie." Also "There has never been . . . a Japanese garden outside of Japan" (10–11).

22. Japanese-style gardens appear frequently in Western literature,

playing roles from the site of murders (*The Door Between, Shaded Light*) and ritual suicides (*You Only Live Twice*) to evocative settings for children's adventures (*Green Willow*) and magic (*The Wood Wife*). In rare cases, they figure prominently as a symbol for the soul and site of its potential transformation. In Tan Twan Eng's *The Garden of Evening Mists* (New York: Weinstein, 2012), a Japanese-style garden built in the hills of Malaysia is the node of connection between a Japanese imperial gardener in exile and a Chinese Malaysian female judge who wants to create a garden in memory of her murdered sister who, when they were tortured in a war-era prison camp, recalled Kyoto gardens to keep her sanity. The garden is a metaphor for memory, with its ability to transform through the acts of forgetting and remembering. In *The Garden of Vision: A Story of Growth* (New York: Cosmopolitan, 1929), romance novelist-Buddhist popularizer Elizabeth L. Moresby (aka Lily Adams Beck, 1862–1931) uses a garden at a Zen center in Japan as the location for the Anglo-Indian heroine's Zen epiphany.

23. Many of the same qualities, formally and conceptually, apply to modern Japanese landscape woodblock prints. For a related discussion, see Kendall Brown, "A Place for Poetry: Shin-hanga in Modern Japan," in *Kawase Hasui: The Complete Woodblock Prints* (Amsterdam: Hotei, 2003).

Kurisu Notes

1. The Quintet, winner of the National Landscape Award of the American Association of Nurserymen in 1992, is presented in Brad Knickerbocker, "Making a Space for the Heart," *The Christian Science Monitor,* September 6, 1994. Another important early residential garden, later destroyed, is described in Jan K. Whitner, "Composition in Pink: Japanese Color Style for a 'Northwest Natural' Garden," *Garden Design* 8: 4 (Winter 1989/90).

2. The Morikami and Anderson gardens are discussed in the author's *Quiet Beauty.*

3. The symbolism of the garden is presented in the pamphlet, "Rosecrance Healing Garden, a self-guided walking tour map." Rosecrance is the subject of two MA theses: Jessica A. Bergeman, "Evaluating the Healing Effects of Design Elements in Therapeutic Landscapes: A Case Study of Rosecrance Healing Garden" (University of Colorado, Denver, 2012) and Donna C. Santagati, "How Using the Shin-ka Program in a Japanese-style Healing Garden Will Influence the Treatment of Adolescent Substance Abusers" (Adler School of Professional Psychology, 2009).

4. The hospital garden, which won the 2006 Healthcare Environment Award, is featured in articles, including "Healing Reflections," *The Oregonian* (June 8, 2006), *Journal of Japanese Gardening* 60

(November/December 2007) and *The Journal of the North American Japanese Garden Association* (2016).

5. Interviews with John Leonard, Chicago, October 14, 2014 and September 29, 2015.

6. Interviews with David Hooker and Joseph Becherer, Grand Rapids, August 2, 2015.

Uesugi Notes

1. Saburo Morishita, "Good Works and the Question of Self-Presentation in Tenrikyo," *Nova Religio: The Journal of Alternate and Emerging Religions* 9: 2 (2005).

2. Reyner Banham, *Los Angeles: The Architecture of Four Ecologies* (New York: Harper and Row, 1971).

3. This biography derives from an interview with Uesugi in Pomona, May 29, 2004, and Keiji Uesugi and Noel Vernon's biographical study on the website of The Cultural Landscape Foundation. Uesugi and Kōichi Kobayashi translated Eckbo's *Landscapes for Living* into Japanese as *Fūkei de dezain* (Tokyo: Kajima shuppan kaisha, 1985).

4. Articles on the garden include "A Garden in the Traditional Japanese Mode," *Los Angeles Times Home* (April 21, 1985), Richard Fish, "A California Stroll," *Garden Design* 6: 4 (Winter 1987/88) and a feature in *Green Tips* 1 (n.d.), where the low, horizontal orientation and tonal contrast of pool and deck are compared to the pond and ground in the garden at Shisendō in Kyoto. Another residential garden, for the Tamura family in Oxnard, is represented by Richard Fish, "Recreating a Classic Garden of Japan," *Southern California Home & Garden* (September 1988).

5. Both gardens are analyzed in Kendall Brown, *Japanese-style Gardens of the Pacific West Coast* (New York: Rizzoli International, 1999).

6. Nakajima's garden is presented in Brown's *Japanese-style Gardens*.

Slawson Notes

1. Slawson's approach and his link to Conder and Newsom is set forth in the Preface to *Secret Teachings in the Art of Japanese Gardens* (Tokyo: Kodansha International, 1987). It is also found in his DVD, *Evoking Native Landscape Using Japanese Principles*, and his article, "Authenticity in Japanese Landscape Design," in Patricia Jonas, ed., *Japanese Inspired Gardens* (New York: Brooklyn Botanic Garden, 2001).

2. This biography is based on information on Slawson's website and in many letters and emails with him over twenty years. Hisamatsu wrote *Zen and the Fine Arts,* published in English in 1971.

3. The garden is presented insightfully in the video by Slawson and

Paul Krause, *In Full Circle: The Japanese Garden as a Work of Art in Progress.*

4. Slawson describes Yasuda's ideas on garden making and his connection to Ogata's garden at the East-West Center in *Secret Teachings*, 136–40.

5. The garden is discussed in detail in Pete Heinzelmann, "The Heinzelmann Japanese Garden," and David Slawson, "The Heinzelmann Garden Design Process," *Roth Journal of Japanese Gardening* 15 (May/June 2000).

6. This garden receives a chapter in *Quiet Beauty*.

Abe Notes

1. The phrase appears on the flap of the ZEN Associates, Inc. business packet., ca. 2000.

2. This biography largely derives from an interview with Shin Abe, Boston, June 12, 2014.

3. Many of these gardens are captured in photos and videos on the ZEN Associates website.

4. Telephone interview with Motohide Yoshikawa, Japan's Permanent Ambassador to the United Nations, August 19, 2015.

5. The history and work of the TKF Foundation is recounted in Tom Stoner and Carolyn Rapp, *Open Spaces, Sacred Places: Stories of How Nature Heals and Unifies* (Annapolis: TKF Foundation, 2008).

6. The ZEN Associates website contains a dynamic video of the EF II garden, including the fountains.

Keane Notes

1. Marc Peter Keane, *The Art of Setting Stones and Other Writings from the Japanese Garden* (Berkeley: Stone Bridge, 2002) 56. The discussion here is from this book.

2. Keane chaired the organization Kyoto Mitate from 1996 to 2002. This biography is based on an interview in Ithaca, May 28, 2014, and Keane's website, mpkeane.com

3. Marc Peter Keane, "Ceramics from the Garden," Youtube. Posted March 15, 2013.

4. The art section on Keane's website has links to the *Omega Point* and *Miwa-an* projects. The Six Friends Garden is explained through a video in the garden section.

5. The garden was built soon after Keane published "The Japanese Garden as Journey," in Patricia Jonas, ed., *Japanese-inspired Gardens* (New York: Brooklyn Botanic Garden, 2001).

6. The perspective of the bryologist, Stephanie Stuber, is found at bryophile.blogspot.com

Acknowledgments

It is a privilege to thank the many people whose work and generosity produced this book. As with *Quiet Beauty*, photographer and friend David Cobb is the eye that brings gardens to life on the printed page. His photos reveal what words struggle to convey. The staff at Tuttle Publishing again displayed professionalism and dedication in every part of the project.

This book is the product of the garden makers as well as the countless artists in the fields of construction and garden care who create and foster gardens. I am deeply grateful to Hōichi Kurisu, the late Takeo Uesugi, David Slawson, Shin Abe and Marc Keane for sharing their vision and their words. I am equally indebted to the generous patrons, home-and-garden owners and public and commercial garden managers who allowed us to publish their gardens and their thoughts. Behind those people are many staff and family members who are also part of this story. A great delight in researching this book was meeting garden volunteers and supporters whose insights helped me realize the profound values of Japanese-style gardens today.

Another pleasure was working with seminar students whose research, ideas and questions shaped my thinking. I would like to thank Loretta Ramirez, Kay Kamiya, Nareh Marootian, Mano Takegami, Trina Brown, Dominique Garcia, Cassie Urena, Claudia Serrano, Christa Weston and (for her insight on Marc Keane) Alexandra Macheski. I am grateful to my colleagues in the Japanese garden field and the members of the North American Japanese Garden Association whose work, knowledge and inspiration are making Japanese gardens part of a better world. As always, I am most thankful for the help of my wife and work partner, Kuniko Brown.

Select Bibliography (Influential Books for Japanese-style Gardens)

Note: First edition publication dates are given although many of the books have multiple editions and printings.

Brown, Kendall, *Japanese-style Gardens of the Pacific West Coast.* New York: Rizzoli, 1999.

____, *Quiet Beauty: The Japanese Gardens of North America.* Rutland, VT: Tuttle, 2013.

Conder, Josiah, *Landscape Gardening in Japan.* Tokyo: Kelly and Walsh, 1893.

DuCane, Florence and Ella, *The Flowers and Gardens of Japan.* London: A.C. Black, 1908.

Engel, David, *Japanese Gardens for Today.* Tokyo: Charles Tuttle, 1959.

Funk, Brian and Sarah Schmidt, eds., *Japanese-style Gardens.* Brooklyn: Brooklyn Botanic Garden, 2015.

Gotō, Seiko and Takahiro Naka, *Japanese Gardens: Symbolism and Design.* London: Routledge, 2016.

Ishimoto, Tatsuo, *The Art of the Japanese Garden.* New York: Crown Books, 1958.

Itoh, Teiji, *Space and Illusion in the Japanese Garden.* New York: Weatherhill/Tankōsha, 1973.

Jirō Harada, *The Gardens of Japan.* London: Studio Limited, 1928.

____, *Japanese Gardens.* New York: Charles T. Branford, 1956.

Jonas, Patricia, ed., *Japanese-inspired Gardens: Adapting Japan's Design Traditions for Your Garden.* Brooklyn: Brooklyn Botanic Garden, 2001.

Keane, Marc P., *Japanese Garden Design.* Rutland, VT: Tuttle, 1996.

____, *Japanese Garden Notes: A Visual Guide to Elements and Design.* Berkeley: Stone Bridge, 2017.

Kuck, Lorraine, *The Art of Japanese Gardens.* New York: John Day, 1940.

____, *One Hundred Kyoto Gardens.* London: Kegan Paul, 1937.

Kuitert, Wybe, *Themes in the History of Japanese Garden Art.* Honolulu: University of Hawai'i Press, 2002.

McDowell, Jack, ed., *Sunset Ideas for Japanese Gardens.* Menlo Park, CA: Sunset Books, 1968.

McFadden, Dorothy Loa, *Oriental Gardens in America: A Visitor's Guide.* Los Angeles: Douglas-West, 1978.

Mori, Osamu, *Typical Japanese Gardens.* Tokyo: Shibata, 1962.

Morse, Edward S., *Japanese Houses and Their Surroundings.* New York: Harper & Brothers, 1885.

Newcomer, David, *Public Japanese Gardens in the USA: Past and Present.* Falcon Books, 2007.

Newsom, Samuel, *Japanese Garden Construction.* Tokyo: Dōmoto, Kumagawa and Perkins, 1939.

____, *A Japanese Garden Manuel for Westerners: Basic Design and Construction.* Tokyo: Tokyo News Service, 1965.

____, *A Thousand Years of Japanese Gardens.* Tokyo: Tokyo News Service, 1953.

Nitschke, Günter, *Japanese Gardens: Right Angle and Natural Form.* Cologne: Taschen, 1993.

Osgood, Harriet (Mrs Basil Taylor), *Japanese Gardens.* New York: Dodd, Mead, 1912.

Saitō, Katsuo, *Japanese Gardening Hints.* Tokyo: Japan Publications, 1969.

Saitō, Katsuo and Sadaji Wada, *Magic of Trees and Stones.* Tokyo: Japan Publications, 1965.

Sawyers, Claire, ed., *Japanese Gardens*, special edition, *Brooklyn Botanic Garden Record*, 1990.

Seiki, Kiyoshi, Masanobu Kudō and David Engel, *A Japanese Touch For Your Garden.* Tokyo: Kodansha International, 1980.

Slawson, David, *Secret Teachings in the Art of Japanese Gardens.* Tokyo: Kodansha International, 1987.

Takei, Jirō and Marc P. Keane, *Sakuteiki: Visions of the Japanese Garden.* Rutland, VT: Tuttle, 2008.

Tamura, Tsuyoshi, *Art of the Landscape Garden in Japan.* Tokyo: Kokusai bunka shinkōkai, 1935.

Tatsui, Matsunosuke, *Japanese Gardens.* No. 5, The Japan Tourist Library, Tokyo: Japan Travel Bureau, 1934.

Yashiroda, Kan, ed., *Japanese Gardens and Miniature Landscapes: A Handbook*, special edition, *Brooklyn Botanic Garden Record*, 1961.

Other Resources

Journal of Japanese Gardening/Sukiya Living.

Journal of the North American Japanese Garden Association.

japanesegardening.org/

www.najga.org/

Right Garden of Quiet Listening, Carleton College, Northfield, MN.

Published by Tuttle Publishing, an imprint of Periplus Editions (HK) Ltd

www.tuttlepublishing.com

ISBN: 978-4-8053-1386-2

Distributed by

North America, Latin America & Europe
Tuttle Publishing
364 Innovation Drive, North Clarendon, VT 05759-9436 U.S.A.
Tel: 1 (802) 773-8930; Fax: 1 (802) 773-6993
info@tuttlepublishing.com; www.tuttlepublishing.com

Japan
Tuttle Publishing
Yaekari Building, 3rd Floor, 5-4-12 Osaki, Shinagawa-ku, Tokyo 141-0032
Tel: (81) 3 5437-0171; Fax: (81) 3 5437-0755
sales@tuttle.co.jp; www.tuttle.co.jp

Asia Pacific
Berkeley Books Pte. Ltd.
61 Tai Seng Avenue, #02-12, Singapore 534167
Tel: (65) 6280-1330; Fax: (65) 6280-6290
inquiries@periplus.com.sg; www.periplus.com

20 19 18 17 10 9 8 7 6 5 4 3 2 1

Printed in Malaysia 1707TW

Stoner residence, Annapolis, MD.

ABOUT TUTTLE

"Books to Span the East and West"

Our core mission at Tuttle Publishing is to create books which bring people together one page at a time. Tuttle was founded in 1832 in the small New England town of Rutland, Vermont (USA). Our fundamental values remain as strong today as they were then—to publish best-in-class books informing the English-speaking world about the countries and peoples of Asia. The world has become a smaller place today and Asia's economic, cultural and political influence has expanded, yet the need for meaningful dialogue and information about this diverse region has never been greater. Since 1948, Tuttle has been a leader in publishing books on the cultures, arts, cuisines, languages and literatures of Asia. Our authors and photographers have won numerous awards and Tuttle has published thousands of books on subjects ranging from martial arts to paper crafts. We welcome you to explore the wealth of information available on Asia at **www.tuttlepublishing.com.**